Jim Zuckerman's Secrets to Great Photographs

diGital eFfects

diGital eFFects

JIM ZUCKERMAN

David & Charles

A DAVID & CHARLES BOOK

First published in the UK in 2001
First published in the USA in 2001 by North Light Books, Cincinnati, Ohio

A catalogue record for this book is available from the British Library.

ISBN 0 7153 1264 2

Printed in China by Leefung-Asco Printers for David & Charles
Brunel House Newton Abbot Devon

Edited by Brad Crawford
Interior design by Brian Roeth
Interior layout by Linda Watts

DEDICATION | *To Dia, who helped me explore inner depths.*

ACKNOWLEDGMENTS

I want to thank my friend Scott Stulberg for his invaluable help in keeping me abreast of new developments in graphics software and for acting as my twenty-four–hour tech support hotline.

ABOUT THE AUTHOR

Jim Zuckerman left his medical studies in 1970 to turn his love of photography into a career. He has lectured and taught creative photography at many universities and private schools, including UCLA, Kent State University, the Hallmark Institute of Photography and the Palm Beach Photographic Center. He also has led international photo tours to destinations such as Burma, Thailand, China, Brazil, Eastern Europe, Alaska, Greece, Papua New Guinea and the American Southwest.

Zuckerman specializes in wildlife and nature photography, travel photography, photo- and electron microscopy, and digital special effects.

Zuckerman is a contributing editor to *Petersen's Photographic Magazine*. His images, articles and photo features have been published in scores of books and magazines including several Time-Life Books, publications of the National Geographic Society, *Outdoor Photographer*, *Outdoor and Travel Photography*, *Omni Magazine*, *Condé Nast Traveler*, *Science Fiction Age*, Australia's *Photo World* and Greece's *Opticon*. He is the author of seven photography books: *Visual Impact*; *The Professional Photographer's Guide to Shooting and Selling Nature and Wildlife Photos*; *Outstanding Special Effects Photography on a Limited Budget*; *Techniques of Natural Light Photography*; *Jim Zuckerman's Secrets of Color in Photography*; *Fantasy Nudes*; and *Capturing Drama in Nature Photography*.

His work has been used for packaging, advertising and editorial layouts in thirty countries around the world. Jim's images have also appeared in calendars, posters, greeting cards and corporate publications. His stock photography is represented by Corbis Images.

table of contents

introduction

Where does creativity come from? I really have no idea. But I do know that everyone has creative ability. Some of us must overcome fear or procrastination or a lack of confidence, but underneath those superficial defense mechanisms is an artist yearning for a means of expression. This book is about stimulating that creativity within you.

Each chapter that follows discusses specific techniques and procedures in digital imaging, specifically, manipulating photographs. To get the most out of the caption information for each set of pictures, you should be sitting at your computer and following along as I describe the steps involved in creating each image. But the book is not about learning any particular computer program. I do, in fact, tell you how I achieved each effect, but Adobe Photoshop and Corel Painter are very deep programs. Others have written comprehensive books about both of them. I do not pretend to elucidate the inner workings of either Photoshop or Painter here. Instead, my goal is to start your creative juices flowing by showing you how I

have used these programs. Once you see what's possible, and once you realize that these techniques are easily within your grasp, you can apply this information to your own work and create images that will give you a wonderful sense of accomplishment.

You can use either a Windows or Macintosh platform with this book. I currently have a Macintosh G4, but virtually all the commands in Photoshop and Painter are identical, with a few minor exceptions. Most of the pictures in this book were taken with a medium format camera system, the Mamiya RZ 67, because I prefer the superior resolution over 35mm. However, the films today are so good that a fine-grain film shot in the 35mm format will indeed produce a professional-looking result.

The scanner I used for the entire book was the Imacon Flextight Photo. You should purchase the best scanner you can afford, because the adage "Garbage in, garbage out" is absolutely true. If your scans aren't high resolution, and if they haven't retained shadow and highlight detail in your original photograph, your end result will suffer. You can now purchase a new film scanner for less than $3,000 that will do

35mm to 6 × 7cm scans, whether negative or transparency. I would recommend a unit that offers a dynamic range of 3.6 or higher. Dynamic range refers to a scanner's ability to retain the shadow and highlight detail that appears in your images. The higher the number, the better.

In Europe and America, some photographers have been shooting color negative film and then scanning the negs. This gives them greater exposure latitude when shooting the film. The downside is that you lose color saturation, but if your goal is simply making color prints on your desktop, this is not a bad way to go. You can always increase color saturation when printing.

One last point: All photographers have their own vision, their own artistic sense of the world. Unless you are trying to satisfy a client in a work-for-hire situation, the pictures you make should please you. If they don't please your mother, or a teacher, or your father-in-law, it doesn't matter. You will love photography only if you love the pictures you make. If others like them too, great. If not, too bad.

introduction to photoshop:
simulating darkroom techniques

chapter | **ONE**

first learned Adobe Photoshop by duplicating conventional photographic effects. I had spent many years working in the darkroom, so now I took the same concepts and re-learned them using a computer. Initially, I tried varying the exposure, sepia toning images, diffusing, applying filter effects, and lightening or darkening specific areas of an image similar to burning and dodging in the darkroom. Next, I learned to adjust the contrast of an image and manipulate the color balance. I then added to my repertoire double exposures, sandwiches and the addition of textures.

At first, I found the computer to be extremely frustrating. In the darkroom, the hands-on experience was so familiar. I could touch printing paper, adjust a lens, work with filters, burn and dodge with my hands, and vary development time. Sitting in front of the computer, I only had a keyboard and a mouse (or Wacom tablet). I must admit that in the beginning there were times when I wanted to throw my computer out the window!

Unlike the darkroom, however, the digital process allowed me to work in a lighted room, without the toxic fumes of chemicals, and I was able see the results in real time on the large monitor. If I didn't like the effect, I could simply 'undo' it and begin again. I quickly realized that the computer was an extraordinary tool. As the digital approach to photographic manipulation become more familiar, I never looked back.

introduction to photoshop:
simulating darkroom techniques

Applying Tones

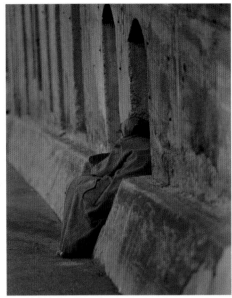

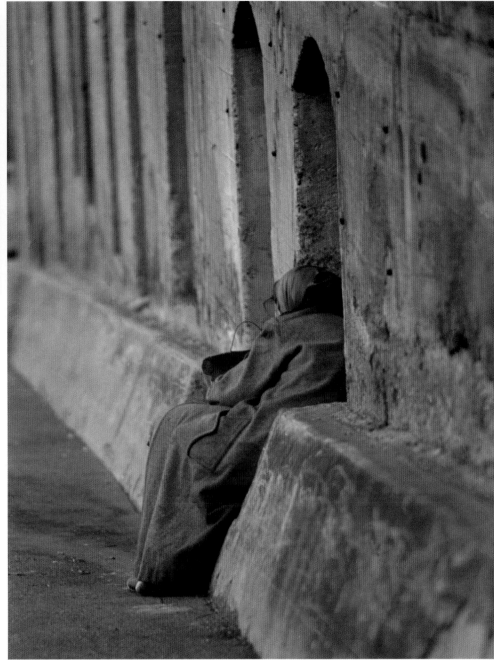

I took the original shot (above) of this homeless woman in Los Angeles in black and white in 1969. However, had the original been a color slide or negative, a sepia tone could be applied only after it was converted to black and white in Photoshop. Using the pull-down menus, the commands are: **Image: mode: grayscale**. Click OK in the dialog box to discard color information.

Since this shot was black and white, I scanned the negative, and then converted it to a positive image with **Image: adjust: invert**. Next, I used **Image: mode: duotone**. In the dialog box that opens, I hit the arrow next to "monotone" and chose "duotone." In the new box that opens, I clicked the right-hand white box next to Ink 2. I selected the color for a sepia-toned image. (Sepia is a light brown, and brown is a dark form of orange.) You will see that the choices for tones seem endless. In the darkroom, the options for toning are limited to sepia, selenium and a few others. In the digital process, there are 16.7 million colors to choose from!

I clicked OK and then clicked OK again in the duotone options dialog box. Finally, using **File: save as**, I named and saved the sepia version of the photo (above right).

The difference between **save as** and **save** is that the former saves a new file and retains the original, while the latter saves the new version *over* the original, thus eliminating the original image from the hard drive. To avoid redundancy, for the remainder of the book I will not mention the last step (**File: save as**) in the captions.

Canon FT QL, 200mm telephoto, exposure information unrecorded, Kodak Tri-X film, handheld.

5

Softening Images With Diffusion

There is a big difference between blurring an image and diffusing it. Diffusion leaves the image sharp, yet soft, retaining detail. There is a glow around the defined lines of the subject. A blurred image loses detail. The digital diffusion I prefer is KPT Gaussian glow, from Kai's Power Tools, for use in Photoshop. It doesn't look exactly like a diffusion filter over the lens, but it is close. It is a very artistic type of diffusion.

To soften this portrait of an Indonesian bride I photographed in Yogyakarta (right), I used the pull-down menu **Filter: blur: KPT Gaussian glow**. By holding down a number key as you apply the filter, you can increase or decrease the amount of diffusion (the higher the number, the more diffusion). In this example, I used 5. I then used the **cropping tool** in the tools palette to crop the image (the cropping tool is located in the upper left box along with the **marquee tools**).

You can apply KPT Gaussian glow more than once. The more times you apply it, the more diffused the image becomes.

Mamiya RZ 67 II, 350mm telephoto, 1/30, f/5.6, Fujichrome Provia 100, tripod.

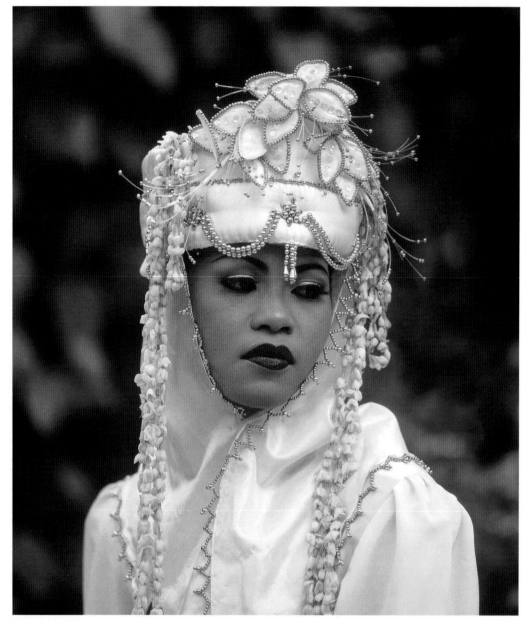

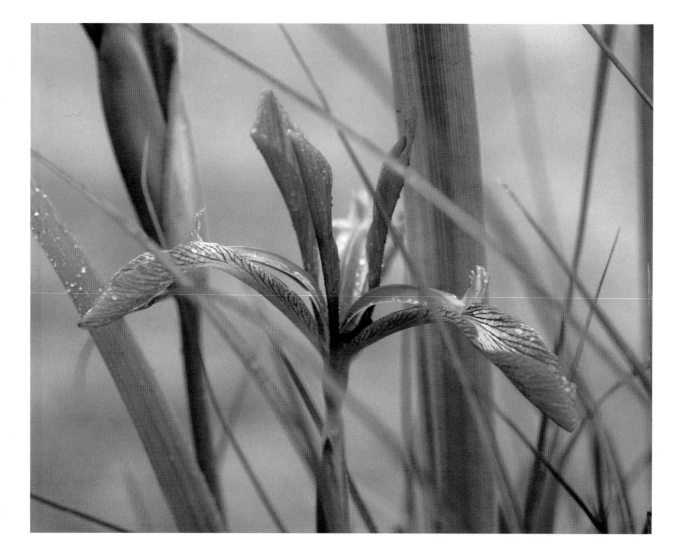

Another example of diffusion can be seen in this iris I photographed at the edge of a pond in Michigan (above). However, in this instance I applied the filter KPT Gaussian glow twice. Then, to alter the color of the flower, I used **Image: adjust: hue/saturation**. This is one of my favorite tools to alter color in a photograph. By moving the hue slider bar to the right, the purple color in the iris became magenta.

The last thing I did was lighten the image and alter the contrast a little. Using **Image: adjust: levels**, I moved the right-hand slider to the left until the highlights brightened to my liking.

Mamiya RZ 67 II, 110mm normal lens, 1/4, f/11, Canon 500D diopter, Fujichrome Velvia, tripod.

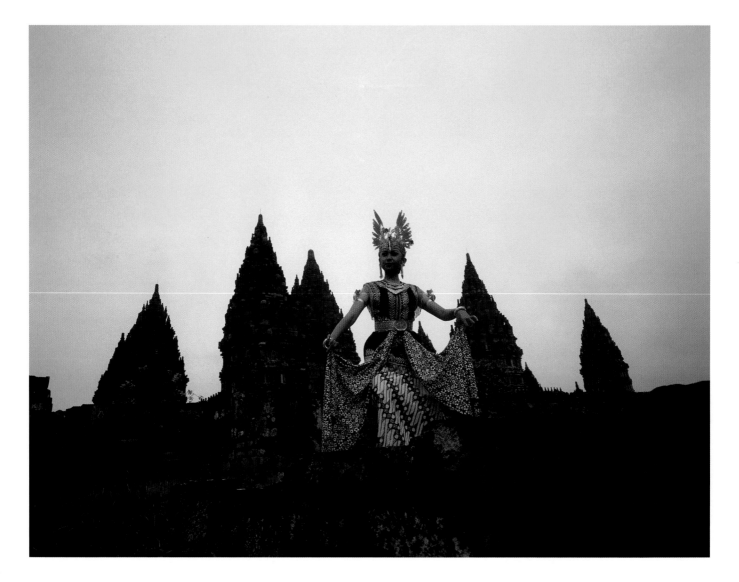

I took the photograph above of a Javanese dancer at Prambanan Temple in Indonesia. I had hoped for sunrise lighting, but at 7:30 A.M. the sky was dull and overcast. The original shot was underexposed because I mistakenly allowed the white sky to adversely affect the camera's TTL meter. I should have known better.

To salvage the image, I first lightened it by using **Image: adjust: levels**. You can also use Image: adjust: brightness/contrast, but I prefer the former because there is more control over the subtle changes in density and contrast. I moved the three sliders until I liked the result. Then, with **Image: adjust: hue/saturation**, I moved the **saturation** slider bar to the right to increase saturation. This didn't change the color relationships, but it increased the saturation of all the colors. I thus circumvented the flat and unattractive morning light by exaggerating the color. With **Filter: blur: KPT Gaussian glow** I diffused the image to give it an ethereal quality.

Finally, I used the **cropping tool** in the tools palette to transform a horizontal image into a vertical one.

Mamiya 7, 43mm wide angle, 1/60, f/5.6, Fujichrome Velvia, tripod.

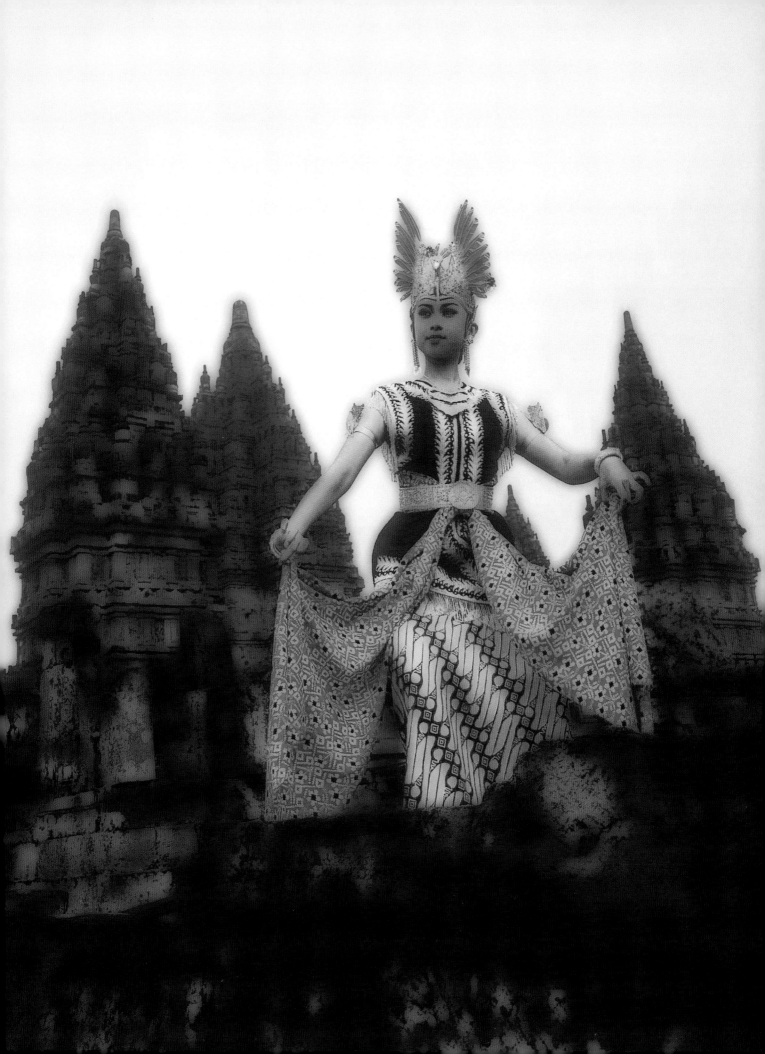

CORRECTING FOR ENVIRONMENTAL CONDITIONS

In recent years Cairo has become extremely polluted. The rich blue sky we are so accustomed to seeing above the pyramids is often thick with smog. Polarizing filters mitigate this decrease in contrast and color saturation, but only to a certain degree. Even Fujichrome Velvia, a very saturated film with excellent contrast, can't cut through thick pollution (right). However, Photoshop takes care of the problem perfectly.

To increase contrast, I clicked **Image: adjust: levels** and adjusted the slider bars until I liked the results. Then I used **Image:**

adjust: hue/saturation and did two things. First, I moved the **saturation** slider bar to the right, which increased the saturation of the overall picture. Then, next to the word "master" in the dialog box, I clicked on the arrow and selected "blue" and then "cyan." I moved the **saturation** slider bar to the right, increasing the saturation of only blue and cyan, respectively, leaving the other colors in the shot unaffected. This enriched the color of the sky.

Mamiya RZ 67 II, 50mm wide angle, 1/60, f/8, Fujichrome Velvia, tripod.

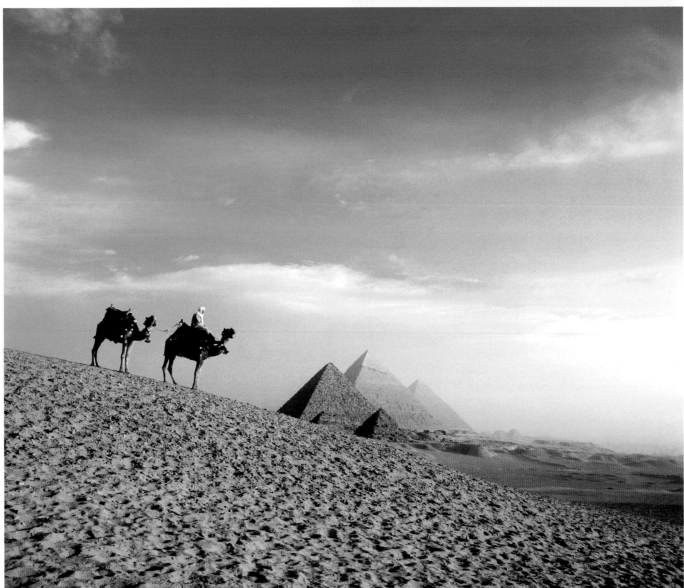

SIMULATING DARKROOM FILTERS

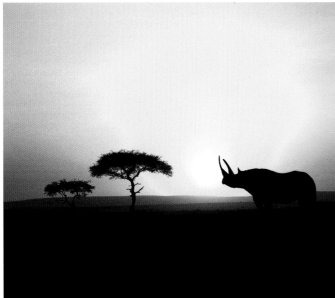

To simulate the addition of filters found in the darkroom, I started with a silhouetted rhino I photographed in Tanzania (left). The sunrise colors were natural[1]—I didn't use any filters. Within Photoshop, I used **Image: adjust: hue/saturation** to change the colors from the warm yellows of "sweet light" to what might be a hazy moonrise with the cool colors of night. Using the **hue** slider bar, I moved it until I liked the change. Then, in **Image: adjust: levels**, I moved the middle slider to the right, decreasing exposure in the midtones to suggest night. Finally, I cropped the image with the **cropping tool**. The result offers a very different feeling from the original.

Mamiya RZ 67 II, 500mm APO telephoto, 1/250, f/6, Fujichrome Provia 100, camera rested on beanbag in Land Rover.

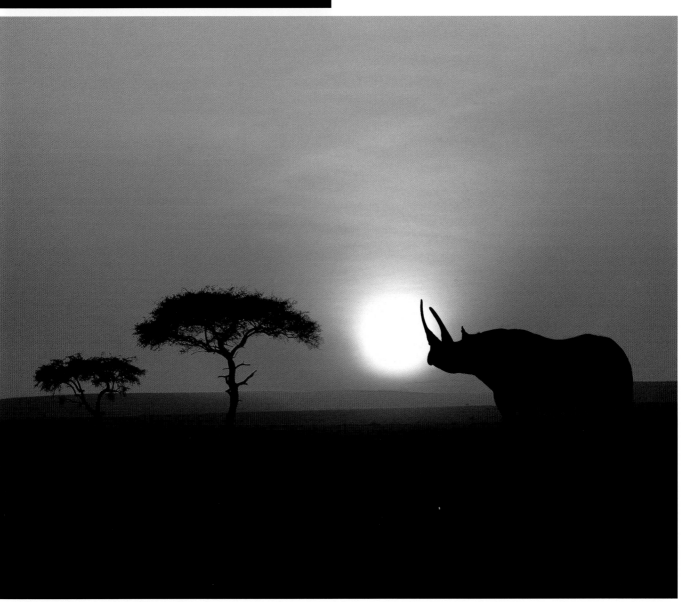

Correcting for Artificial Lighting

King Tut's tomb near Luxor, Egypt, is illuminated with fluorescent tubes that produce an unattractive yellow color, detracting from the original paint dyes (right). I didn't have an FLD filter, which partially or totally corrects for this color shift. (The amount of correction depends on the type of tubes lighting an interior.) Instead, I took the pictures knowing I could correct the problem digitally.

I used two dialog boxes to bring the colors of the tomb back to their correct shades as I remembered them: **Image: adjust: hue/saturation** and **Images: adjust: color balance**. I went back and forth between the two, making minor adjustments until I was happy. I can't recall each individual step because it took quite a bit of time, finesse, and trial and error to make the correction.

Similar to a technique I used in the image of the pyramids on page 12, I adjusted the saturation of only one color at a time to fine-tune the result. Making subtle changes to the color balance of an image is one of my favorite strategies.

Mamiya 7, 43mm wide angle, 2 seconds, f/22, Fujichrome Velvia, tripod.

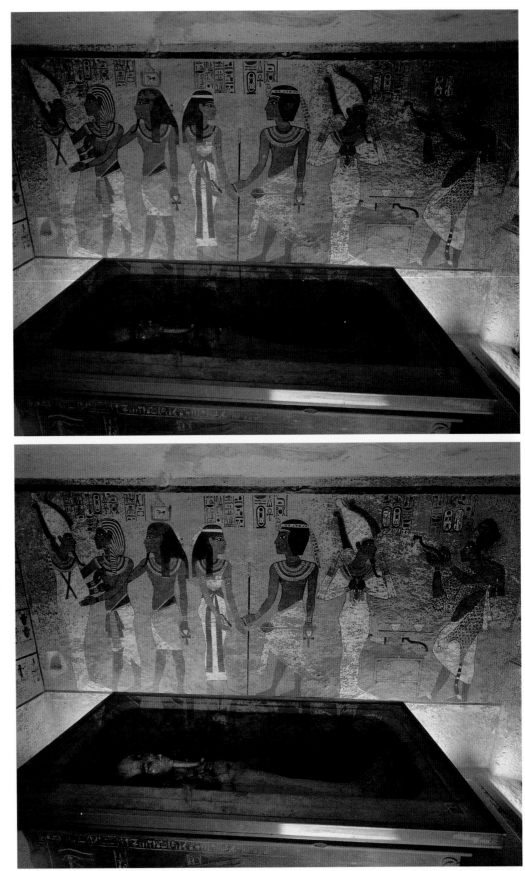

Correcting for Dim Outdoor Lighting

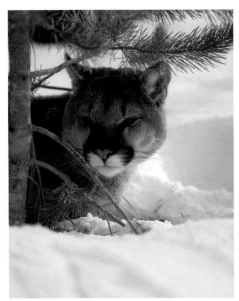

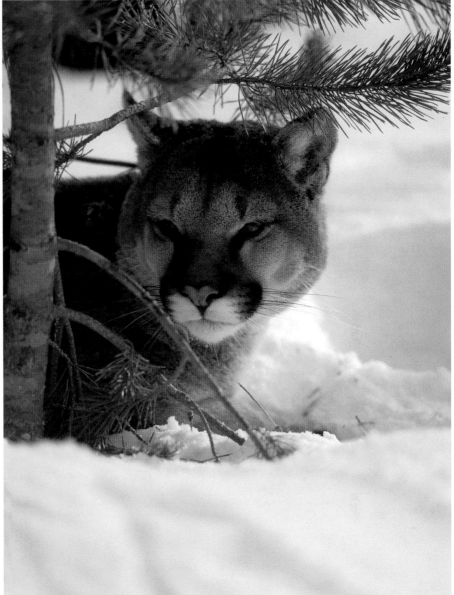

I photographed a mountain lion crouching under a pine tree in the Pacific Northwest (above), but the cat's face turned out relatively dark, particularly when seen against the snow. The deep overcast sky prevented much light from bouncing off the snow onto the animal, and the shade of the tree made this a very challenging exposure.

In the tools palette, the burn/dodge tool toggles back and forth. The hand icon burns an image, which adds exposure or density; the black disc with a handle is the dodge tool, which lightens a specific area of the picture. To lighten a small portion of the lion's face, I clicked the dodge tool and selected a brush size from the brushes palette to define the size of the area affected by the tool. I gradually lightened the fur at the center of the face, then used a smaller brush to lighten the eyes slightly.

Keep in mind that if your shadows have no detail, you're out of luck. You can't bring back what isn't there.

Mamiya RZ 67 II, 350mm telephoto, 1/60, f/5.6, Fujichrome Provia 100F pushed one f-stop, tripod.

MAKING A DIGITAL SANDWICH

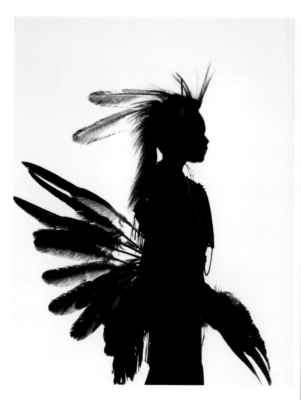

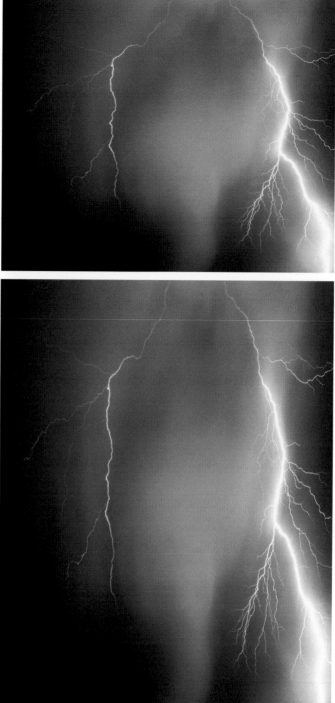

In conventional photography, a sandwich is where two pieces of film (usually slide film) are held together and projected onto a screen or printed. If the two originals are properly exposed, the sandwich is often too dark due to the cumulative density of two pieces of film. Therefore, the sandwich is usually duplicated onto slide-duplicating film to correct the exposure. Within Photoshop you can create what looks like a sandwich and easily correct the density problem.

The two original shots I used for the sandwich are a semi-silhouetted portrait of a Navajo boy in Canyon de Chelly, Arizona (above left), and a lightning bolt shot in Tucson (top right). I used **Image: image size** to vertically resize the horizontal picture of lightning. The original pixel dimensions of the photo were 4,096 wide and 3,277 high. I unchecked the "constrain proportions" box and typed in 3,277 wide and 4,096 high to vertically

stretch the lightning (above). I copied this new picture to the clipboard (a temporary holding place) with **Select: all** (this selects the entire photograph) and then **Edit: copy**. I then opened the shot of the Navajo boy with **File: open**.

You can use the pull-down menu command **Edit: paste** to place the picture being held in the clipboard over the photo that is open and highlighted on your

Both shots Mamiya RZ 67 II, 250mm telephoto, Fujichrome Velvia, tripod. Navajo boy: 1/250, f/11; Lightning: several seconds until a burst of lightning occurred, f/5.6.

desktop. It's important to make sure both shots are the same size, as defined in the **Image: image size** dialog box. I placed the lightning over the shot of the Navajo boy. This created a new layer, which could be seen in the

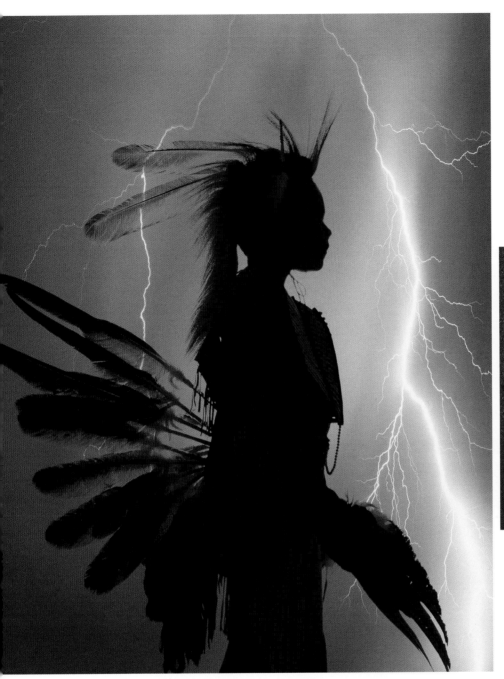

layers palette. In the upper left portion of this palette, there is a box labeled "normal" with arrows just to the right. When you click these arrows, you are presented with several choices that combine the two images in different ways. I liked **darken** to achieve the effect of a sandwich (which pull-down option you select varies depending on the two shots being combined.) Then in the upper right of the same palette, I changed the opacity of the pasted picture (the lightning) to 80 percent. Before I saved the image, I flattened the layers using **Layer: flatten image**. This reduces the file size of the picture, which takes less storage space on a hard drive. Finally, to transform the image into a high-contrast black-and-white shot with a pronounced texture, I used **Filter: sketch: graphic pen** (above right).

MAKING A SECOND DIGITAL SANDWICH

A classic sandwiched image is with a silhouette in nature and a sunset. I photographed this live oak tree in the rain against a dull white sky, and I shot the beautiful sunset above my house in California.

I opened the tree photo (right) in Photoshop with **File: open** and used **Select: all** to select the entire image. I used **Edit: copy** to place the photo in the clipboard, and I closed the picture with **File: close**. I opened the sunset (below right) and pasted the tree over it with **File: paste**. The new layer showed up in the **layers palette**, and I used the pull-down arrows within the palette to choose **multiply**. This gave me the effect of a sandwich, but it was still a bit dark. In addition, the density of the white sky (even a white sky has some degree of density) decreased the saturation of the sunset.

I clicked **Layer: new: adjustment layer**. This command allows you to affect only one layer at a time instead of the entire image. I wanted to alter the sky, not the tree. I made sure the sunset layer (in this case, the "background" layer) was highlighted. Within the dialog box that was revealed, I selected **levels**, and clicked the box that says "group with previous layer" and hit OK. The levels dialog box opened, and I moved the sliders until the sky brightened.

Finally, I went through the same procedure to increase saturation in the sky only: **Layer: new: adjustment layer**, select **saturation**, click "group with previous layer," click OK and adjust the saturation of the sky. I flattened the image with **Layer: flatten image** and saved it.

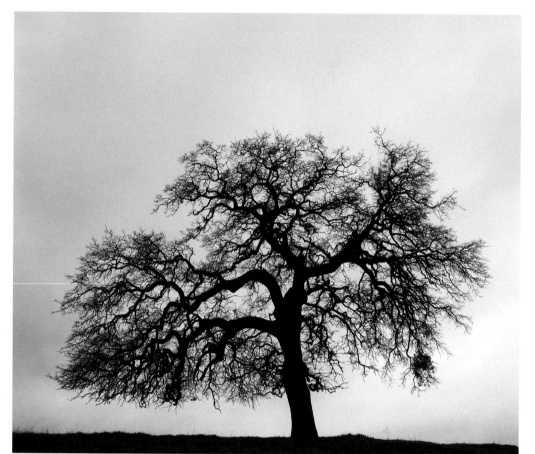

Tree: Mamiya RZ 67 II, 250mm telephoto, 1/8, f/8, Fujichrome Velvia, tripod. Sky: Mamiya 7, 43mm wide angle, 1/30, f/4.5, Fujichrome Velvia, tripod.

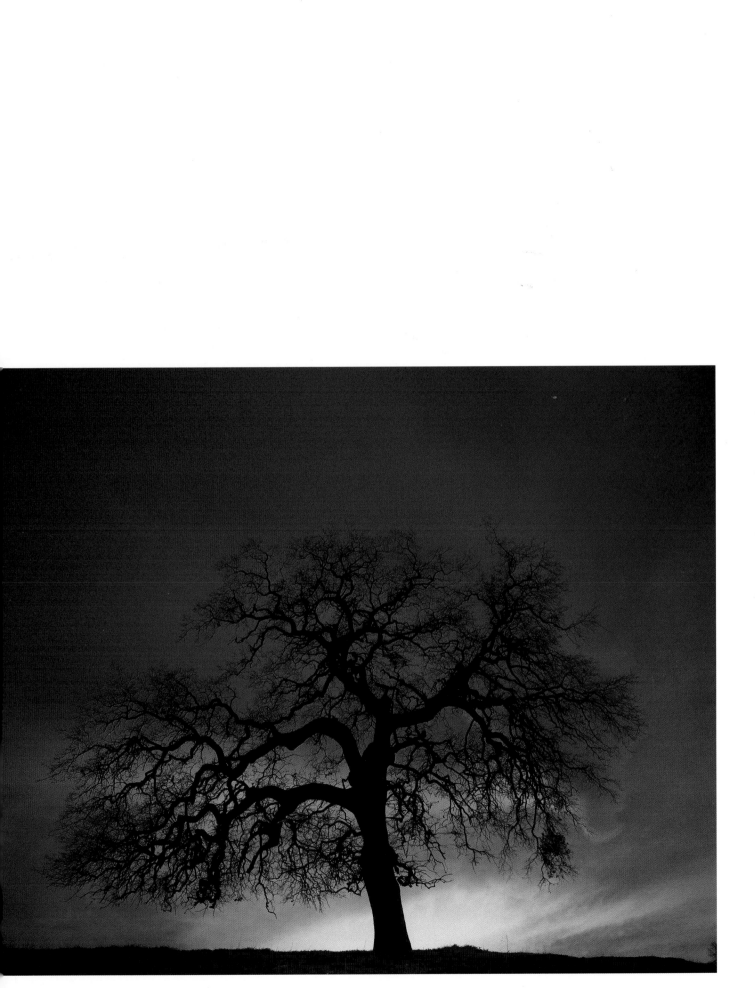

ASSEMBLING A DIGITAL "DOUBLE EXPOSURE"

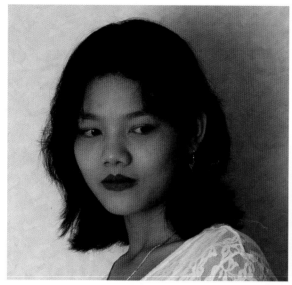

There is a difference between a sandwich and a double exposure. When you sandwich two slides, the dark portions of one image (such as black hair) remain dark, blocking out the colors in that part of the composition. In a double exposure, unexposed film is struck by light twice. If one of those "strikes" is dark hair, this is basically unused film. When the second strike occurs, the black hair is replaced by the colors in the other shot.

In the light areas, sandwiches cause the colors in one shot to replace the high key portions of the second picture when the two pieces of film are placed in contact. The same two shots double-exposed react differently. The white area (say, a white sky) over-exposes the colored portion of the second shot, assuming we are talking about the corresponding portions of the composition.

I double-exposed this portrait of a young woman (above left) with diffused autumn foliage. I use the term "double-exposed," but I didn't actually use a camera to create this image. I used Photoshop to simulate the effect.

I first selected a portion of the portrait using the **rectangular marquee tool** in the tools palette, then copied that portion of the image with **Edit: copy** to the clipboard. I opened the autumn foliage image and chose **Edit: paste** to place the portrait over the abstraction of color. Since the area of the pasted image was smaller than the background (because I cropped it), I clicked **Edit: transform: scale**. This gave me corners by which I could pull the image and stretch it over the entire colored background. I hit **return** (or enter).

In the **layers palette**, I used the pull-down arrows and chose

Model: Mamiya RZ 67 II, 250mm telephoto, 1/30, f/4.5, Fujichrome Provia 100, window light, tripod. Foliage: Mamiya RZ 67 II, 250mm telephoto, 1/15, f/4.5, Fujichrome Velvia, taken through rain on windshield, handheld.

soft light. The choice of the pull-down command to achieve a double exposure will vary depending on the two originals. I now had a double exposure. I then flattened the image with **Layer: flatten image** and finally adjusted the contrast by choosing **Image: adjust: levels** and moving the slider bars.

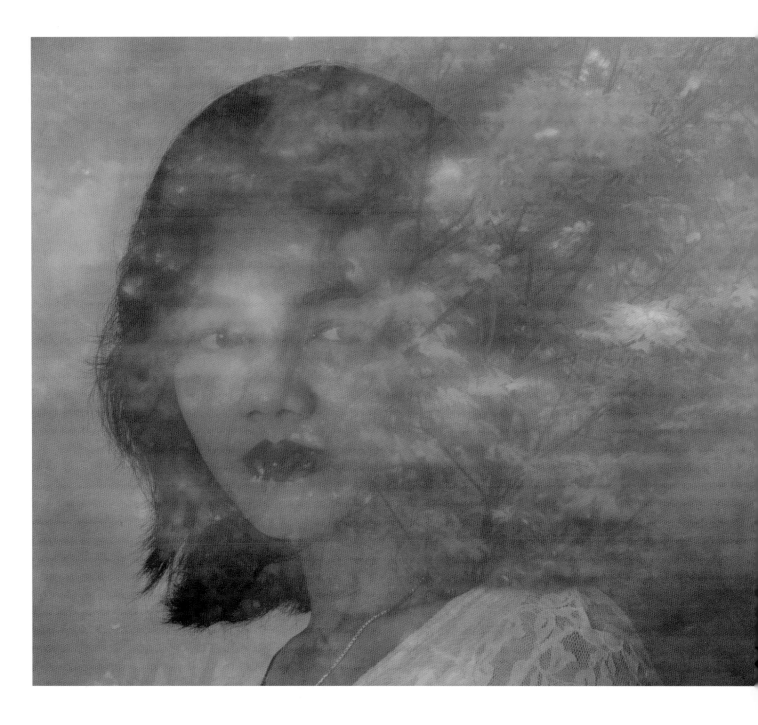

ADDING TEXTURES TO IMAGES

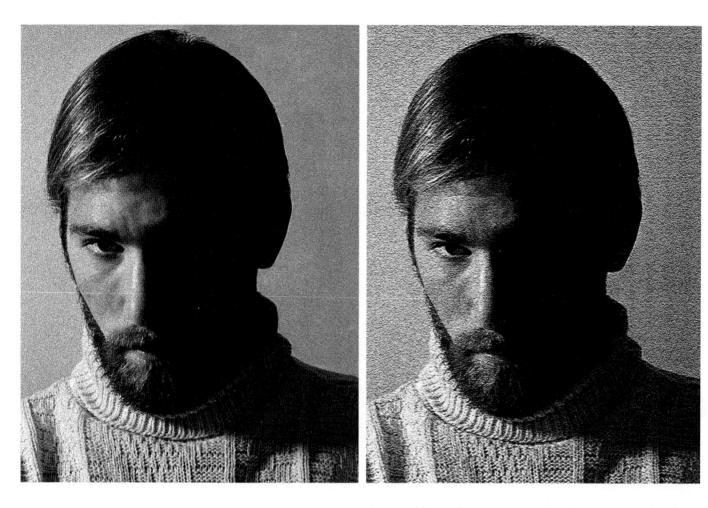

You can add myriad textures to photographs in Photoshop. I applied the two shown here, craquelure (above) and burlap (right), to a self-portrait taken in 1970 with my first camera and a single photoflood.

To create the craquelure texture, I used **Filter: texture: craquelure** and made my selec-tions within the dialog box for the amount of texture I wanted. I made the burlap texture by click-ing **Filter: texture: texturizer** and selecting the burlap option.

Canon FT QL, 100mm macro, expo-sure unrecorded, Kodak Tri-X film, tripod, self timer.

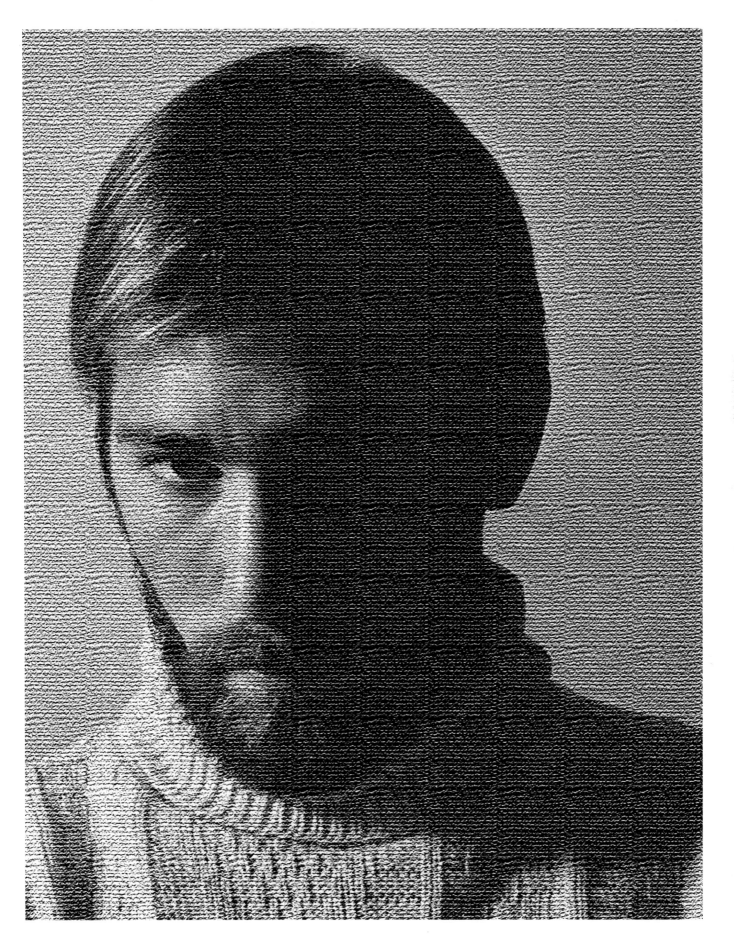

artistic
filter effects

chapterTWO

One of the first filters I tried when I bought Photoshop was **solarize**. In the darkroom, this is a challenging technique, but digital solarization is simple. I opened the photo of the caribou in Alaska (below) and applied **Filter: stylize: solarize**. Sometimes this filter leaves the image too dark, and I have to lighten it using **Image: adjust: levels**, as I did here.

Mamiya RZ 67, 350mm APO tele-photo, 1/125, f/5.6, Fujichrome Provia pushed two f-stops, tripod.

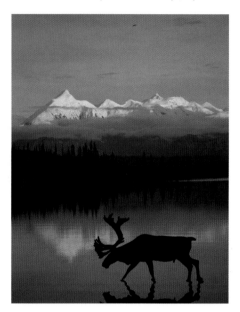

In conventional photography, a filter alters the color of the original subject, eliminates glare or in some limited way introduces distortion. Examples of the latter are diffusion, star filters and prismatic effects. Within Photoshop a filter is the term used for many different types of effects.

Many filters are included when you purchase Photoshop and they can all be found under the pull-down menu Filter. You can add additional groups of filters, called plug-ins, to the program after it has been installed on your computer. Examples of plug-ins are the Andromeda series, Kai's Power Tools, nik Color Efex Pro! and Xaos Tools. All large software suppliers offer these for sale.

Using a filter is one of the easiest ways to create a unique effect on your original photograph. If you don't like the effect, simply undo it and try again (to undo the last effect hit Command + Z on a Mac, or Control + Z on a PC). In this chapter, I show you some of my favorite filters; however, keep in mind that a filter may alter two different images in very different ways. The color, contrast and complexity of the image determine how the filter effect works on each picture.

One of the things you'll want to try is combining filter effects. By applying more than one filter to an image, you abstract the original more and more until it resembles a work of art. Be judicious in assessing the results, though. Sometimes applying too many filters to an image turns it into an unrecognizable mess; other times the end result can be stunning.

artistic
filter effects

Adding Depth With the Emboss Filter

You can use the emboss filter to add relief, or depth, to an image. It can be quite effective with portraits, whether they be fashion models or faces with age and character, as in this Greek Orthodox priest I photographed on the island of Corfu (below). I clicked **Filter: stylize: emboss** and selected the parameters in the dialog box that suited me. The mostly gray embossed result had traces of color, so I used **Image: mode: grayscale** to discard all color information. Then I used **Image: mode: levels** to adjust the contrast so the final image (bottom) had more punch.

Mamiya RZ 67 II, 350mm APO telephoto, 1/125, f/5.6–f/8, Fujichrome Velvia, tripod.

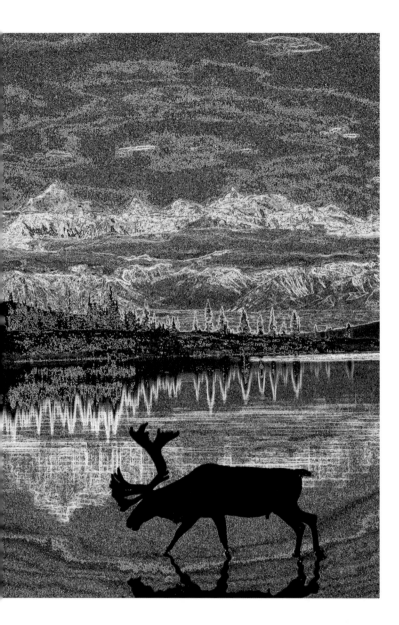

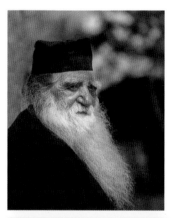

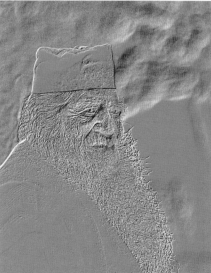

HEIGHTENING FILTER EFFECTS BY CROPPING

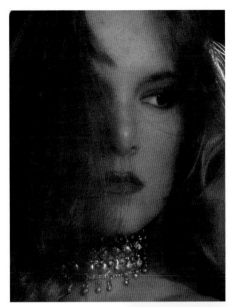

All of my high-resolution scans are approximately 40 megabytes. Some of the Photoshop plug-in filters are only mildly effective with large file sizes. You can see their effect more dramatically when you crop the image. In other words, a filter may have a very different effect on a 1 megabyte photo than on the same image scanned as 40 megs.

On the portrait at left, I applied **Filter: brush strokes: angled strokes**, but I was disappointed that the unique pattern of the filter wasn't very apparent.

I enlarged the face using the **magnify tool** in the tools palette until I could clearly see the strokes laid down by the filter. I cropped the picture with the **cropping tool** and then clicked **Image: adjust: hue/saturation** to change the color and increase the saturation.

Mamiya RZ 67 II, 250mm telephoto, 1/250, f/11, Fujichrome Velvia, Speedotron Power Pack with two strobe heads, one Photoflex softbox, tripod.

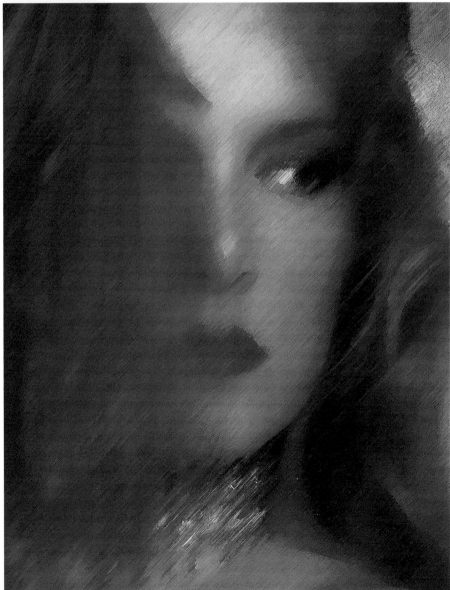

COMBINING FILTERS

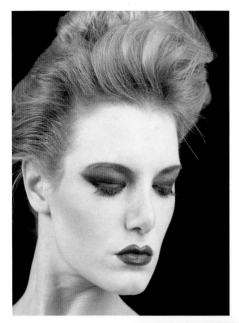

I applied two filters successively to derive the drawinglike rendition of this portrait (left). First I used **Filter: stylize: solarize** and then **Filter: sketch: graphic pen**. The model used makeup to lighten her skin and darken her eyes and lips. When I took the original image, I used a light reading to overexpose the skin to create a contrasty look. This technique reduced the face to simple graphic shapes.

Mamiya RZ 67 II, 250mm telephoto, 1/250, f/11, Fujichrome Velvia, Speedotron Power Pack with two strobe heads, one Photoflex softbox, tripod.

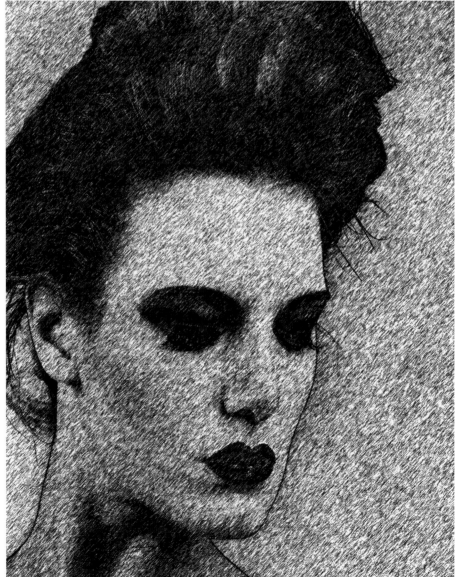

EXPERIMENTING WITH KALEIDOSCOPIC FILTERS

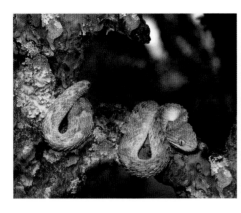

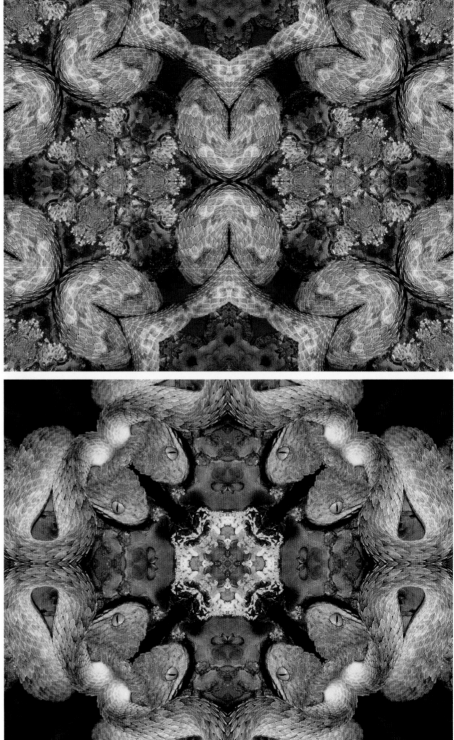

One of my favorite plug-ins is Terrazzo by Xaos Tools. It acts like a kaleidoscope by repeating an image in wonderful patterns that will intrigue you. I never get tired of seeing the remarkable designs created from any photograph. Each original photo, in fact, can produce an endless number of patterns, defined by the parameters you set within the dialog box of the software. Of the many kaleidoscopic patterns within Terrazzo, my two favorites, and the ones that made all of the designs you see here, are "turnstile" and "sunflower."

I rendered the African bush viper (above) and the maple tree in autumn (opposite page, top) using **Filter: Terrazzo**. The two versions derived from the maple tree photo demonstrate how diverse the patterns from a single original photo can be.

Mamiya RZ 67 II, 350mm APO telephoto, 1/60, f/8, Fujichrome Velvia, flash fill with Metz 45, tripod.

Mamiya RZ 67 II, 250mm telephoto,
1/30, f/8, Fujichrome Velvia, tripod.

PLAYING WITH METALLIC FILTERS

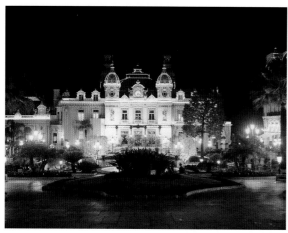

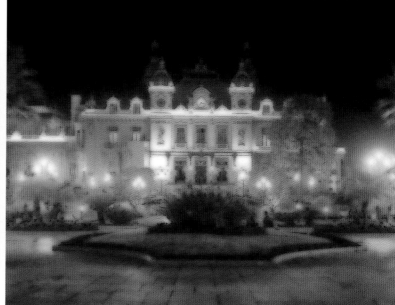

I applied three filters to this night shot of Monte Carlo in Monaco (above). The original colors result from the mercury vapor illumination on the beautiful architecture. First I applied **KPT Gaussian glow**, then using **Image: adjust: hue/saturation**, I increased the saturation of the colors and changed the hue slightly; this introduced magenta into the color scheme (top right). Then, I applied **Filter: metallic filter**. Within the dialog box that opens, I had a choice of brass, aluminum, gold, copper and so on. I chose silver, but this gave me a negative image (right). I wanted a positive rendition, so I clicked **Select: inverse** to reverse the light and dark tones.

Mamiya RZ 67 II, 110mm normal lens, 8 seconds, f/5.6, Fujichrome Velvia, tripod.

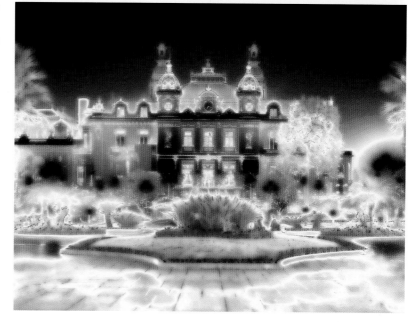

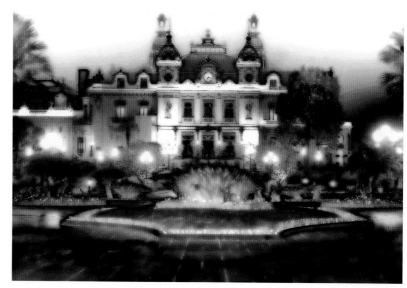

USING THE STAR FILTER FOR ACCENTS

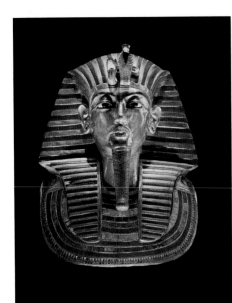

The gold death mask from King Tut's tomb (left) is one of the world's most exquisite works of art. I photographed it in the Cairo Museum in Egypt. No tripods were allowed, so I rested the camera on a glass-enclosed showcase opposite the mask. I used my wallet to cushion the camera against the glass.

To add the glow of a "star," I used **Filter: Andromeda: star**. The dialog box offers many choices. You can define the size of the star, the amount of glow, the length of the beams, the color and several other options.

Mamiya RZ 67 II, 250mm telephoto, 1/2, f/16, Fujichrome Velvia, no tripod.

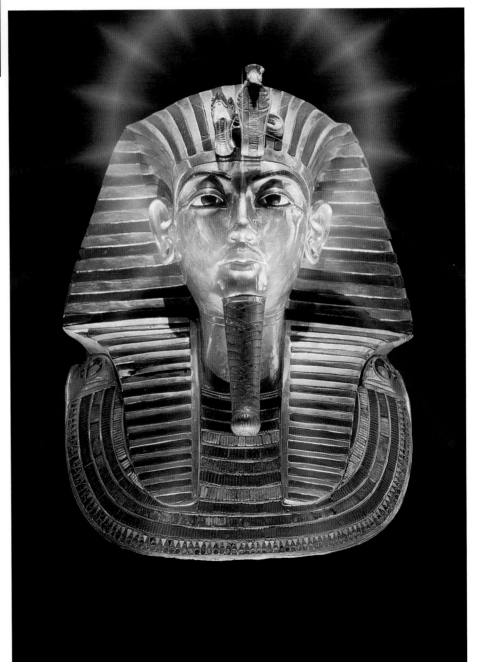

Magnifying Subjects With the Glass Lens Filter

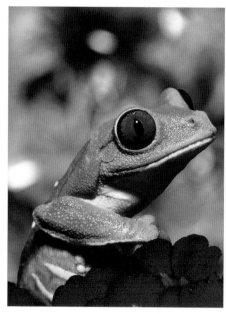

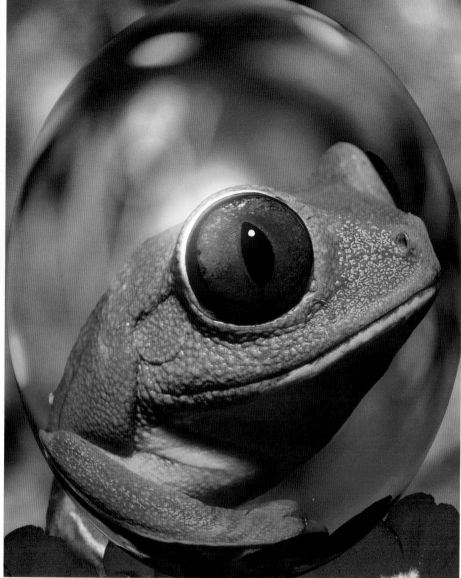

The Kai's Power Tools glass lens filter simulates distortion typical of a magnifying glass. Within the dialog box, you can move the highlight to any point on the bubble, and you can increase and decrease the contrast inside the distortion oval. To create the images of the red eye tree frog, I used **Filter: KPT 3.0: KPT glass lens**. Kai's Power Tools continually comes out with new versions; at this writing I use KPT 3.0, 4.0, 5.0 and 6.0. Each version offers different filters.

Mamiya RZ 67, 110mm normal lens, #1 extension tube, 1/60, f/8, Fuji-chrome Velvia, Metz 45 flash, tripod.

Applying Filters Twice

Sometimes I apply a filter twice in a row to increase the abstraction of the original. This doesn't always work—sometimes the effect reduces the recognizability of the subject—so you'll have to try this on a case-by-case basis.

I transformed this extreme close-up of a baby cheetah (right) by applying **Filter: Artistic: poster edges** two times. I then used **Image: adjust: levels** to lighten the photo a little.

Mamiya RZ 67 II, 250mm telephoto 1/125, f/8, Fujichrome Velvia, tripod.

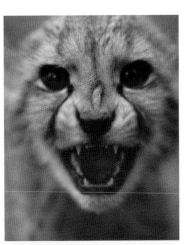

Enhancing Landscape Shots With Graduated Filters

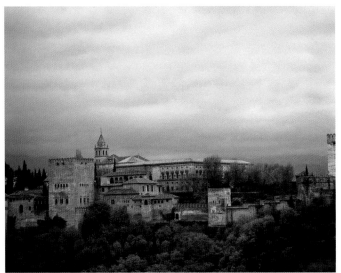

Graduated filters that introduce a neutral density or a colored tone to a photo are popular with photographers in the field, particularly when they are shooting landscapes or architecture with a large expanse of sky in the frame. Now you can use this same technique in Photoshop. The new set of filters from TECHnik called nik Color Efex Pro! (e-mail address: infous@nikmultimedia .com) offers a wide variety of effects that can darken and tone the sky or any other part of an image. I photographed this image of the Alhambra in Granada, Spain, on a very dull day (left). Using **Filter: nik Color Efex Pro: graduated use defined**, I was able to choose not only the introduced color but also the specific placement of the color, saturation and opacity.

Mamiya RZ 67, 250mm normal lens, 1/30, f/5.6, Fujichrome Velvia, tripod.

COMBINING FILTERS FOR ABSTRACT EFFECTS

You can use combinations of filters to increase the abstraction of the original image until, in many cases, the photograph begins to look like a painting. I discuss this in detail in chapter six, but in this portrait of a young Balinese dancer (right), I applied two filters and then altered the color. First I used **Filter: artistic: palette knife** and then **Filter: brush strokes: angled strokes**. Finally, using **Image: adjust: hue/saturation**, I moved the hue slider bar into the blue end of the scale.

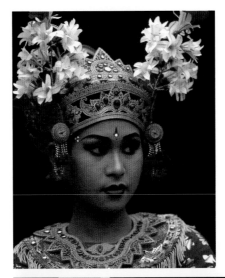

Mamiya RZ 67 II, 250mm telephoto, 1/30, f/4.5, Fujichrome Provia 100, tripod.

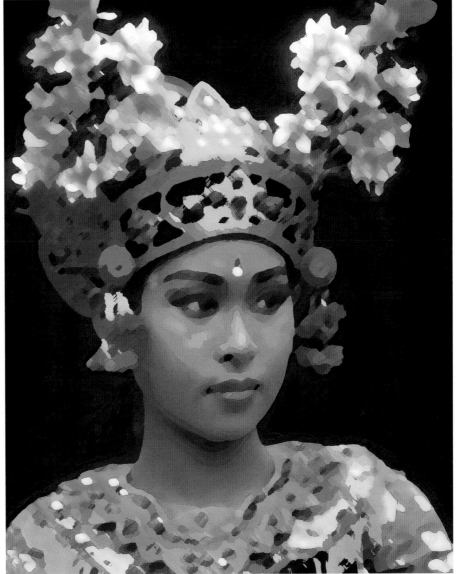

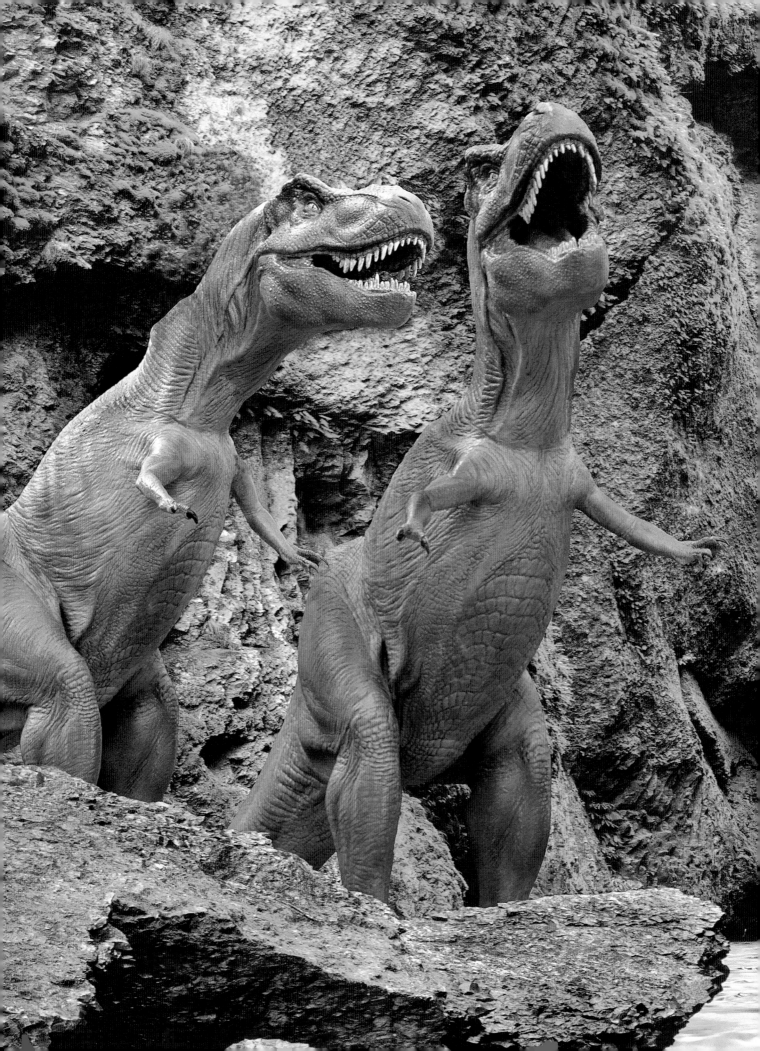

altering
backgrounds

chapter | THREE

There are countless instances when the background behind your subject is less than ideal. It may be cluttered, over- or underexposed, unattractive, distracting or simply less dramatic than you'd like. Photoshop allows you to alter or replace the background so the final result is exactly what you wanted in the first place.

The key to manipulating and replacing a background is the tools you use to select certain portions of the photograph. I primarily use three tools—the **magic wand tool**, the **lasso tool** and the **pen tool**—to separate, or "cut out," the subject from its environment. The magic wand tool makes its selections based on color and contrast. When you double-click the magic wand tool icon, you can adjust the sensitivity in the dialog box. The default is 32. Increasing the number means that when you click the tool within a certain area of the photo, more colors and areas of contrast will be included in the selection. Decreasing the number means the opposite. The magic wand tool works very well when the contrast between the subject and background is very clear such as in the top left photo on page 41 and the top photo on page 42. It should be noted, however, that in many instances the magic wand tool can create a selection with jagged edges. The precise border between an object and its background—on the microscopic level of individual pixels—is not usually a hard edge. Over the width of two, three or four pixels, the colors of the subject and its background blend together. When you use the pen tool, you can define the selection exactly as you want it. When you use the magic wand tool, Photoshop's attempt to give you an accurate selection isn't always as perfect as you'd like. The result is sometimes a jagged border. This can only be seen when you magnify the photo (using the magnify tool) to 100 or 200 percent.

If colors and tones within the subject are close to the background, such as in the photo at left on page 52 (the dark bands on the chameleon are close in tonality to the adjacent background colors), I use the pen tool to separate the two portions of the composition. This is a more precise method where I have complete control. With the image magnified about 200 percent, I use the pen tool to lay down a series of dots at the edge of the subject. The dots are connected to form the selection.

altering
backgrounds

FINE-TUNING TO MATCH SUBJECT WITH BACKGROUND

I selected the background of the arch picture (top left) using the **magic wand tool** (I held the shift key down and clicked on the areas above and through the arch), expanded the selection with **Select: modify: expand** and then feathered the selection one pixel (**Select: feather**) to create a soft transition edge. I then saved the selection with **Select: save selection**.

I opened the new sky photo (top right) and resized it horizontally. In **Image: image size**, I typed in new pixel dimensions: Instead of 3,352 wide and 4,190 high, I chose 4,190 wide and 3,352 high. This distorted the clouds from their original form, but as you can see, clouds are abstract, and the alteration didn't adversely affect the final picture. I copied this to the clipboard and then pasted it into the selection.

In the layers palette, I clicked on the background layer, which was the arch, and darkened it appropriately to match a backlit sky. I did this by using **Layer:** **new: adjustment layer** and clicking on **levels** in the dialog box. Finally, I flattened the layers and saved the new picture, giving it its own name.

Rock arch: 250mm telephoto, 1/60, f/11. Sky: 350mm APO telephoto, 1/125, f/8. Both Mamiya RZ 67 II, Fujichrome Velvia, tripod.

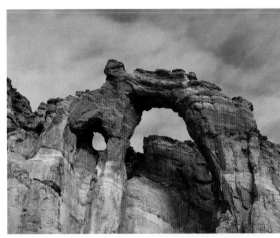

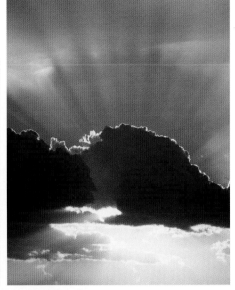

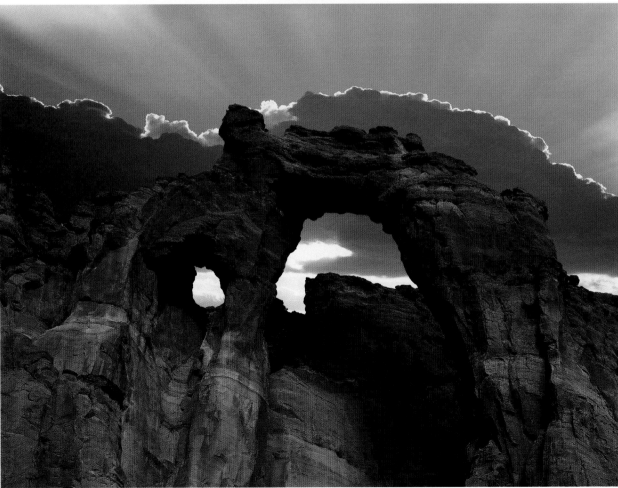

I accomplished this combination of pictures in much the same way as the previous shot. I used the **magic wand tool** in the tools palette to select the sky in this shot of a bristlecone pine tree in California (right). I first clicked on the upper dark portion of the sky using the default of 32. Then, when Photoshop selected only the upper third of the sky, I held down the shift key and used the **magic wand tool** again to add more blue to the selection. I clicked on the middle of the sky and then, still holding the shift key down, I clicked on the blue background just above the foliage. I now had almost the entire sky selected, but the blue seen through the grasses was still outside the selection. I then chose **Select: similar** from the pulldown menu to add all similar hues in the picture the selection. This solved the problem.

Although I now had the entire sky selected, when the background image was replaced with the other photo, a thin blue line around the entire periphery of the tree and the foliage remained where the blue sky had been. To take care of this potential flaw, I used **Select: modify: expand** and chose one pixel in the dialog box. This expands the entire selection outward by one pixel, eliminating the blue line. (Sometimes this requires two pixels.) I then hit **Select: feather** and chose one pixel in the dialog box. This softened the edge of the selection slightly so the tree would better blend with the new sky background where the two images met. I saved the selection with **Select: save selection** should I want to modify or change the background again.

Next, I opened the shot of the storm clouds in Oregon (right), copied it to the clipboard (**Select: all, Edit: copy**) and closed it

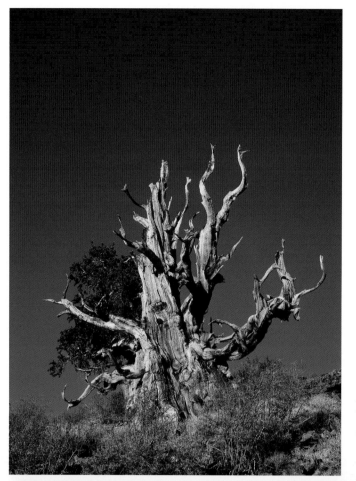

Tree: Mamiya RZ 67 II, 50mm wide angle, 1/15, f/22. Storm clouds: Mamiya 7, 43mm wide angle, 1/30, f/4.5. Both Fujichrome Velvia, tripod.

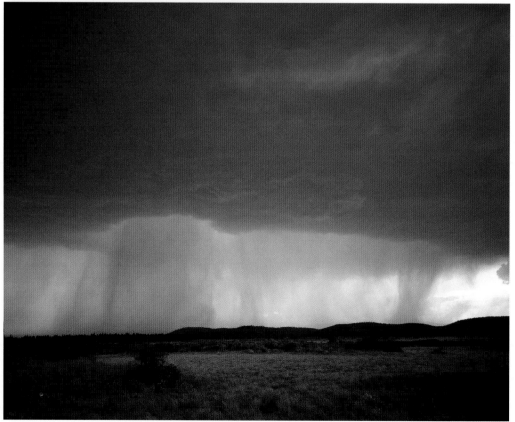

with **File: close**. I then chose **Edit: paste into** to place the new sky into the selection and behind the tree. Note that the replacement sky is a horizontal; it needed to be stretched higher to fill the entire area above the tree in the final vertical composition. I did this with **Edit: transform: scale**, which places a box around the new background. Using the cursor, I pulled the image until it filled the entire sky and then hit **return**, or enter. Clicking on the **move tool** in the tools palette, I moved the clouds into the final position and then flattened the layers with **Layer: flatten**.

Finally, I used **Image: adjust: color balance** to make it more yellow and a little red—simulating the light just before sunset.

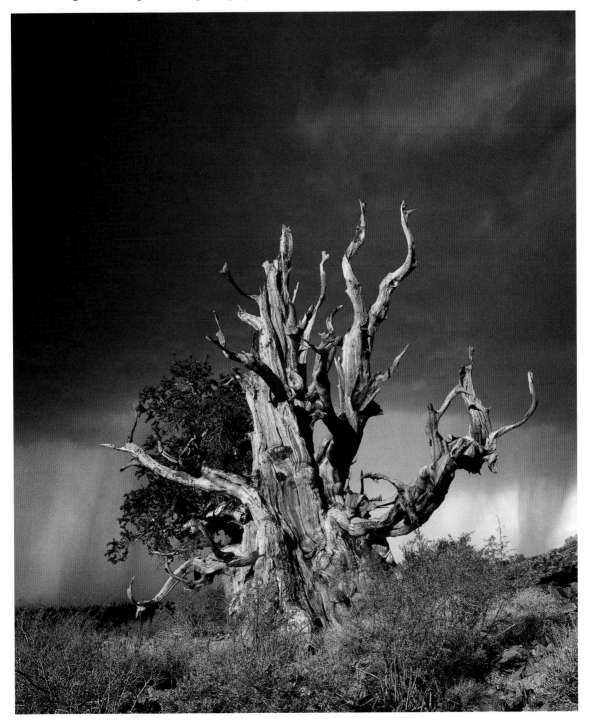

FIXING PERSPECTIVE FOR COMBINED IMAGES

When I photographed this Javanese dancer at the ruins of Prambanan Temple in Indonesia, I was disappointed that the sky was white and featureless (right). I knew, however, that I could remedy the situation when I returned home. I opened the image of the clouds and copied it to the clipboard with **Edit: copy**.

Selecting the sky with the **magic wand tool** was easy since the sky is monochromatic white. I expanded the selection by one pixel (**Select: modify: expand**), feathered the selection by one pixel also (**Select: feather**) and pasted the clouds into the selected area (**Edit: paste into**). I had photographed the clouds in Hawaii in 1975 (below right).

After I put the new sky in, I realized that since I took the original shot of the dancer with an ultra-wide-angle lens, the distant stone structure was leaning inward at an unattractive angle. To fix this, I used the **pen tool** to select only the structure itself. I did this by first enlarging the area 200 percent with the **magnify tool** and then outlining the visible portion of the temple structure with the **pen tool**. When the last dot was connected to the first dot, this completed the path. To convert the path into a selection, I clicked on **paths** in the **paths palette** and clicked on the arrow in the upper right corner of the dialog box. This brings up a pull-down menu, where I selected **make selection**. Another dialog box shows up, where I chose a feather radius of one pixel and clicked OK. I then eliminated the path by choosing **turn off path** in the paths pull-down menu.

Now that I had a selection around the stone structure, I clicked **edit: transform: distort**. Using the box that formed around my selection, I altered

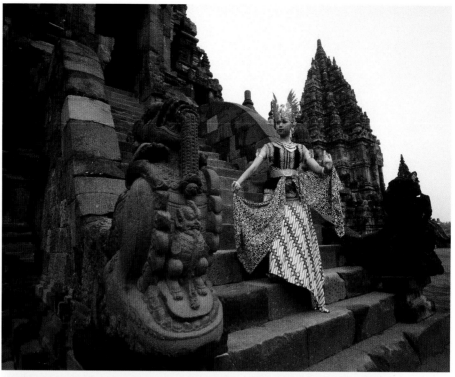

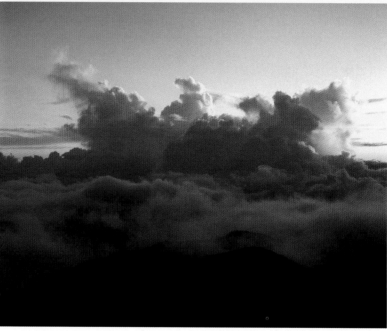

the shape and angle of the temple structure until it looked more accurate. However, a solid color was now where the stonework had been (whatever color is in the background box in the tools palette fills this area). So, with the **clone tool**, I cloned the sky back into this area.

Sky: Mamiya RZ 67, 180mm telephoto, Ektachrome 64, exposure unrecorded. Dancer: Mamiya 7, 43mm wide angle, 1/60, f/4.5, Fujichrome Provia 100, tripod.

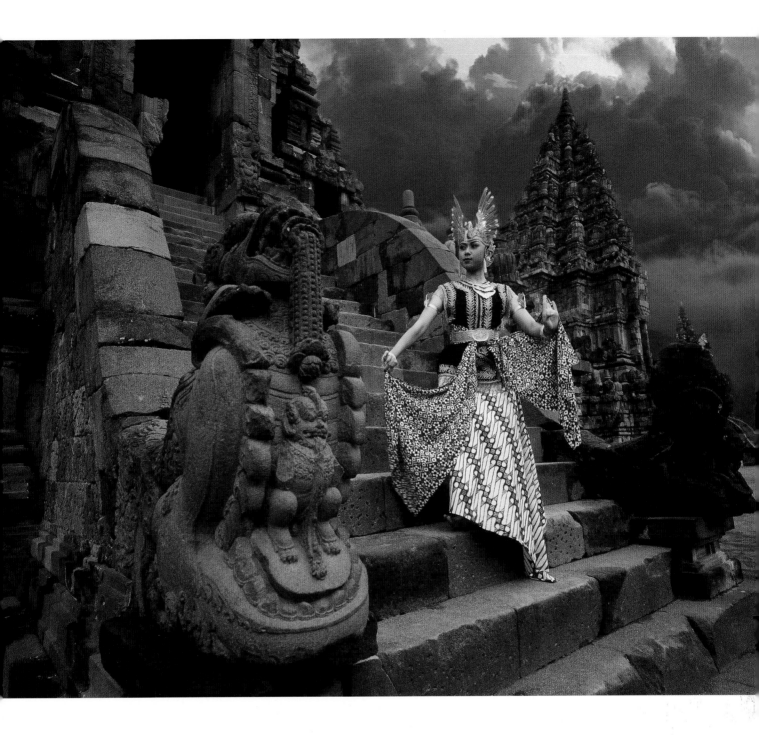

Tweaking Small Imperfections

When I photographed this young girl in Jaipur, India, I shot quickly and didn't notice the small section of blue sky in the background (below left). In the self-critique afterward, I thought it was distracting.

To eliminate it, I selected the blue with the **magic wand tool**, expanded the selection by one pixel with **Select: modify: expand** and then used the **clone tool** to fill in the selection. I held the option key down, and clicked within the soft green foliage to establish the borrowing point for the color. Then I clicked within the selection and replaced the blue sky with the foliage.

Mamiya RZ 67 II, 250mm telephoto, 1/125, f/8, diffusion filter, Fujichrome Velvia, tripod.

PLACING SUBJECTS ON NATURAL BACKGROUNDS

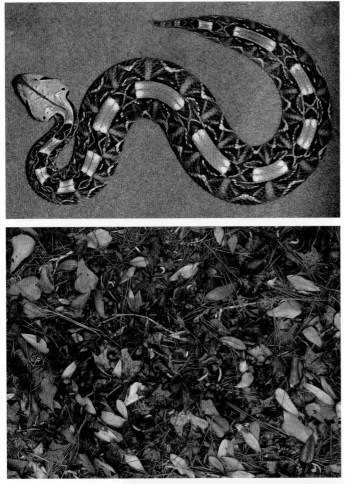

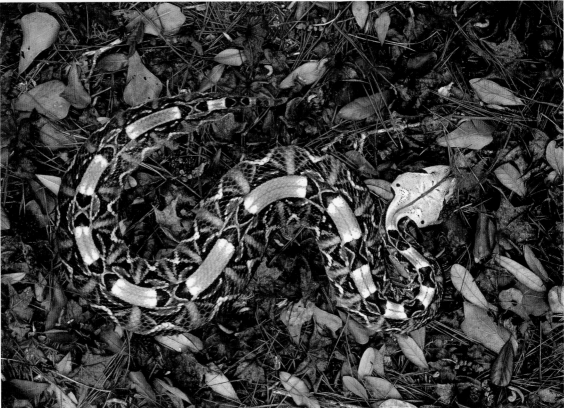

This deadly Gabon viper was too dangerous to photograph outside. The owner of the snake feared it might get away, so we photographed it indoors on the carpet in his apartment (left). I was standing directly above shooting downward (and trying to keep my feet as far away from his head as possible!). The next day, I photographed fallen leaves in the forest (middle left) from the same point of view specifically so I could use it with this snake.

I easily separated the snake from the carpet with the **pen tool** (I probably could have used the magic wand tool, but I wanted a very clean demarcation). Once I did this and converted the path into a selection (as described previously) with a one-pixel feather, I pasted the shot of the leaves into the selection using **Edit: paste into**.

Both shots Mamiya RZ 67 II, 50mm normal lens, Fujichrome Provia 100. Snake: 1/125, f/11, Metz 45 flash, handheld; Leaves: 1/8, f/16, Fujichrome Provia 100 tripod.

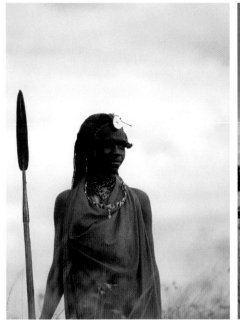

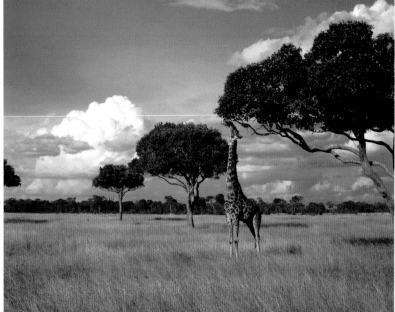

The likelihood of capturing a dynamic portrait of a Masai tribesman with a beautiful image of wildlife in the background is virtually nil. Digitally, however, it is quite feasible.

I used the **pen tool** to precisely separate the Masai from his environment (above left). This was especially important around the details of his hair and near the bottom, where the tawny grass blends with the red fabric. The out-of-focus grasses in front of my subject helped make a convincing composite.

Once I created the path around the Masai, I made a selection as described previously. Then I copied the selection to the clipboard (**Edit: copy**) and pasted it into the landscape with the giraffe using **Edit: paste** (right). To adjust the size of the warrior to fit appropriately with the background, I clicked **Edit: transform: scale**, which put a box around the Masai. Holding the shift key down to prevent the proportions from changing, I grabbed one of the box corners and moved it inward, reducing the size of the layer. Then I hit

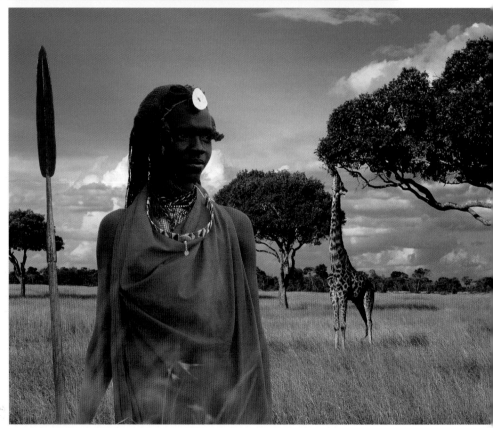

enter. Using the **move tool** in the tools palette, I moved the warrior into place. Finally, I lightened the young man's face slightly with the **burn and dodge tool** (on the dodge mode). Notice that, once again, I combined a vertical shot with a horizontal one.

Warrior: Mamiya RZ 67, 250mm telephoto, 1/125, f/5.6, Fujichrome Velvia, tripod; Giraffe: Mamiya RZ 67, 50mm wide angle, 1/250, Fujichrome Provia, camera rested on beanbag in Land Rover.

Refining Older Photos

I took the picture at right many years ago in infamous Tiananmen Square in Beijing, China. The stroller behind the little boy always bothered me, but I loved the portrait. I remedied the problem by using the **clone tool**. By cloning with various brush sizes, and being careful not to intrude on the edge of the child's magenta shirt (I magnified the image 200 percent with the **magnify tool** in the tools palette), I replaced the stroller with the out-of-focus stone squares. In addition, I cloned out the dark, oblong object in the sky just to the right of the boy's hat.

Mamiya RZ 67, 90mm normal lens, exposure unrecorded, Ektachrome 64, handheld.

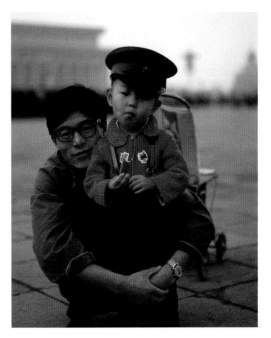

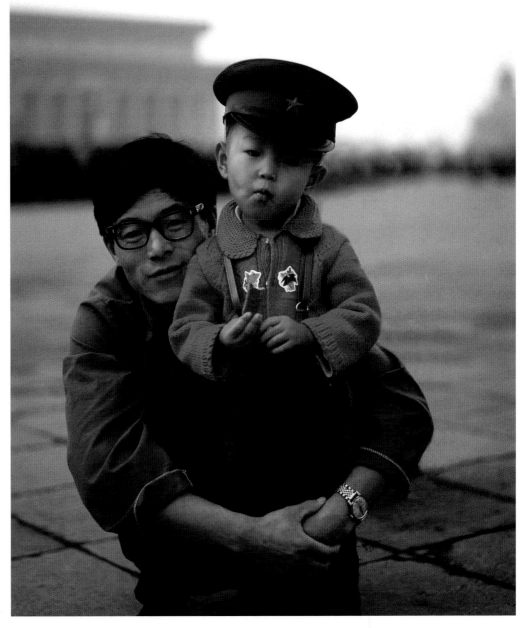

WORKING WITH ADJUSTMENT LAYERS

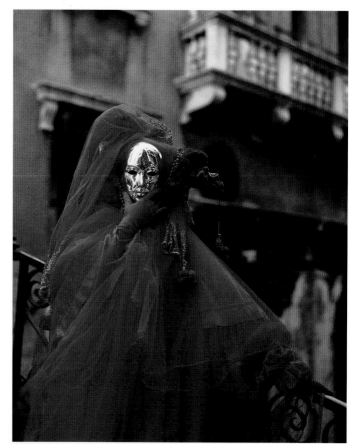

The background in the final image was a second-story window in the Doge's palace in Venice (bottom right). I photographed it at twilight, which accounts for the combination of the blue (deep shade at twilight) and orange (artificial lights) on the stonework and glass. It would have been impossible to take this picture unless both the model and I were elevated on a large platform.

I cut around the carnival costume with the **pen tool** to create the selection. Then I copied it to the clipboard and pasted it into the background using the same commands explained previously. Using the **move tool**, I moved the model into place. I didn't like covering the lion, a famous Venetian landmark, but I had no choice. I then chose **Layer: new: adjustment layer**, and when the new dialog box opened, I selected **hue/saturation** in the pull-down menu. Adjustment layers allow you to work only on the

one layer that is highlighted in the layers palette. In this case, I wanted to change the color of the costume to orange, which I did by moving the hue slider bar until I liked the shade of color. I clicked OK to make the change.

I then flattened the layers with **Layer: flatten image**. Finally, I used **Image: adjust: hue/saturation** to increase the saturation of the entire image.

Both images Mamiya RZ 67 II, Fujichrome Velvia, tripod. Carnival costume: 110mm normal lens, 1/60, f/4; Palace: 350mm APO telephoto, 4 seconds, f/16.

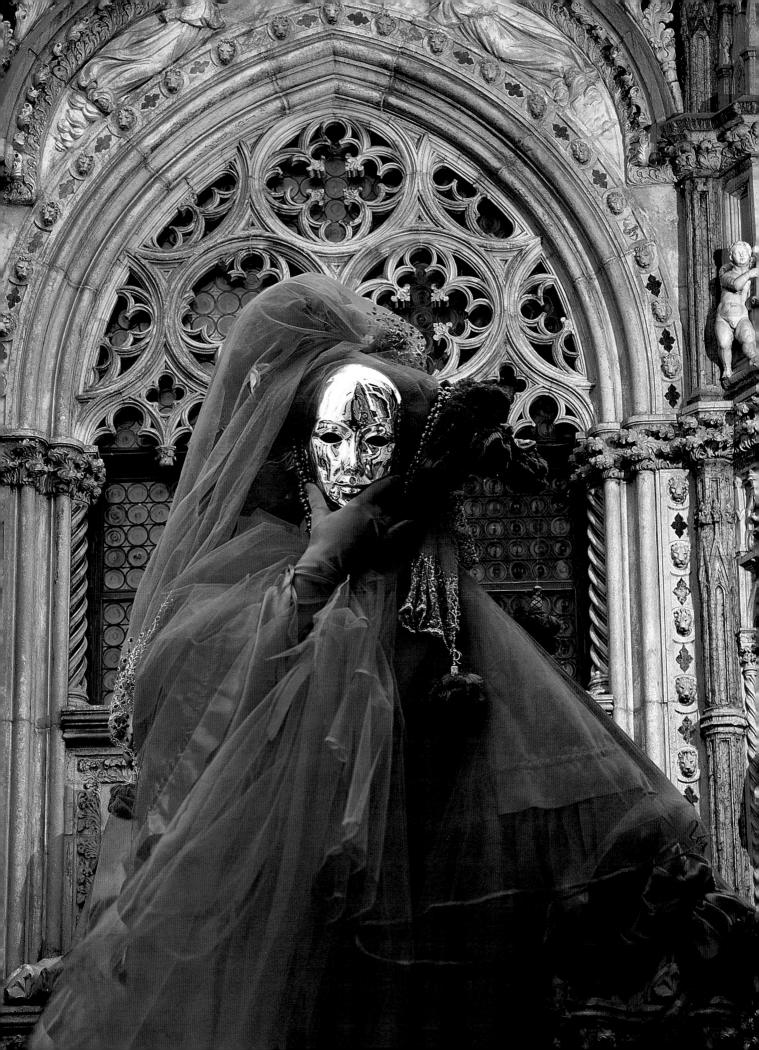

Perfecting Natural Settings

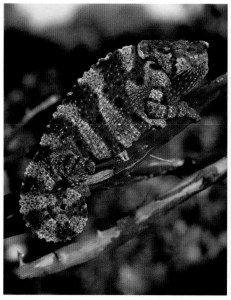

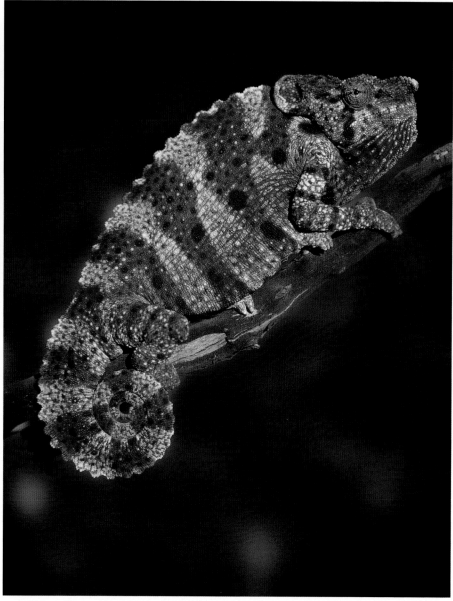

This shot of a Meller's chameleon (above) was good except for the obtrusive multiple tree branches in the background. In nature, we often are forced to capture animals within less-than-ideal environments, but thanks to the computer, this can be corrected.

I outlined the reptile and the branch on which it rested with the **pen tool**. This always takes a lot of time, but it's worth the effort because the result is flawless. Once I made the selection, I clicked **Select: inverse**, which gave me a selection of the entire background and excluded the reptile. Using the **clone tool**, I eliminated the large branch under the chameleon, and then with **Filter: blur: Gaussian blur** I softened the background to simulate the shallow depth of field of a telephoto lens. Within the dialog box of Gaussian blur, I used the slider bar until I liked the amount of blur.

Mamiya RZ 67 II, 250mm telephoto, 1/125, f/4.5, Fujichrome Provia 100, tripod.

ADDING ACCENTS

Placing the moon in an otherwise moonless sky is easy to do. I opened the shot of the moon and encircled the celestial body with the **lasso tool** in the **tools palette**. I wasn't precise in following the outline of the crescent moon, but the line I created was fairly close to the edge. I copied the selection to the clipboard (**Edit: copy**) and the pasted it into the sky over the Duomo in Florence, Italy (**Edit: paste**). I moved it into place with the move tool.

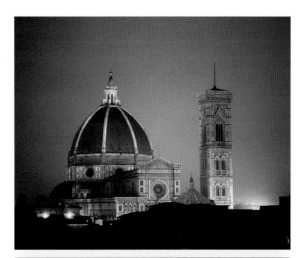

The twilight blue background behind the moon was still visible. To eliminate this, I went to the **layers palette**. The moon was still a separate layer because I hadn't flattened it yet. The upper left-hand pull-down menu in the layers palette has the word "normal" next to the up and down arrows. I clicked on this and chose "lighten." The blue behind the moon disappeared, leaving only the bright crescent.

With the transform command (**Edit: transform: scale**), I reduced the size of the moon until I judged the size to be correct. I rotated it with **Edit: transform: rotate** by using the cursor outside the box and moving it in the direction of the rotation.

Both shots Mamiya RZ 67, Fujichrome Velvia, tripod. Duomo: 110mm normal lens, 10 seconds, f/8; Moon and sky: 350mm APO telephoto, 1/60, f/5.6.

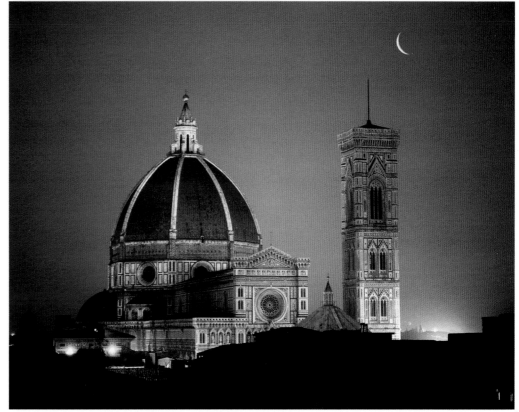

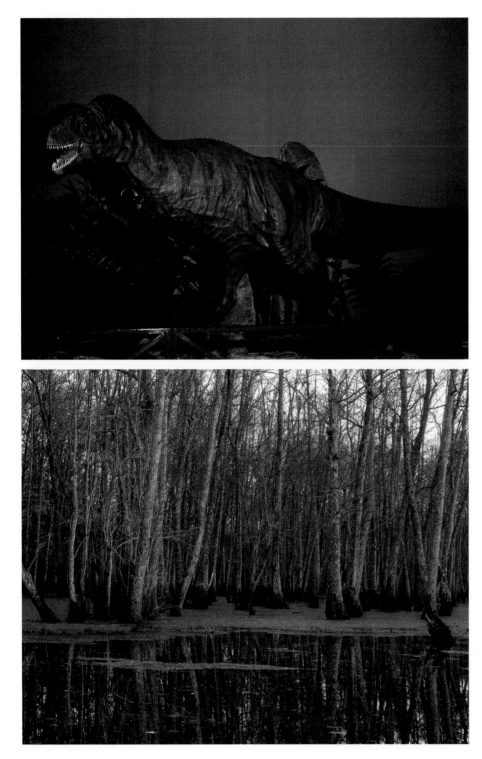

I photographed the large model of an allosaurus in the Los Angeles Natural History Museum (left). The feet were obscured by the railing and somewhat engulfed in shadow. On the computer, I used the **pen tool** to create a path and then made the selection. I copied the selected dinosaur to the clipboard. Since I couldn't see its feet, I eliminated them from my selection.

I opened the shot of a swamp in Alabama (below left) and pasted the allosaurus into the frame with **Edit: paste**. I could disguise the missing feet by suggesting the reptile was in deep water. I made the reflection using the following steps: (1) I pasted the dinosaur again into the swamp background, creating another layer (**Edit: paste**); (2) I flipped the new layer vertically (**Edit: transform: flip vertical**); (3) I moved the inverted layer into place with the **move tool** such that its position simulated a reflection; (4) I lowered the opacity of the inverted layer to 70 percent in the layers palette; (5) I lowered the saturation of the inverted layer with **Layer: new: adjustment layer** by choosing hue/saturation in the dialog box and moving the saturation bar to the left. Finally, using the **burn/dodge tool** I darkened the reptilian skin to eliminate the glare from the on-camera flash I used in the museum.

My last touch was to add the suggestion of mist or low-hanging fog above the water. I used the **lasso tool** to roughly outline an area above the water and around the feet of the dinosaur. I feathered the selection with **Select: feather** and in the dialog box I entered 20 pixels and clicked OK. I then filled the selection (**Edit: fill**) with 20 percent opacity of white color.

The fill command fills a selection with the foreground color (the foreground and background colors are in the large boxes toward the bottom of the **tools palette**).

Allosaurus: Mamiya RZ 67 II, 110mm normal lens, 1/125, f/5.6, Fujichrome Velvia, Metz 45 flash, handheld; Swamp: Mamiya RZ 67, 180mm telephoto, 1/4, f/16, Fujichrome 50, tripod.

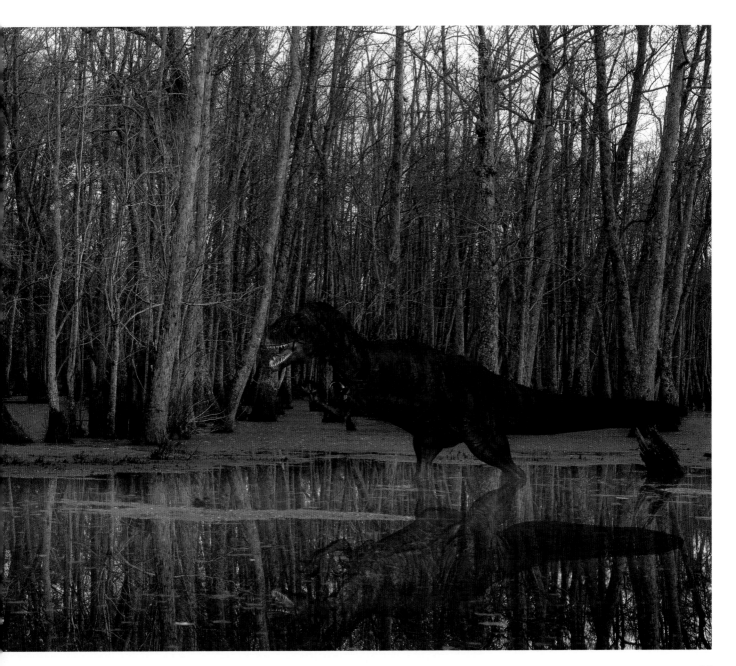

strategies in
combining images

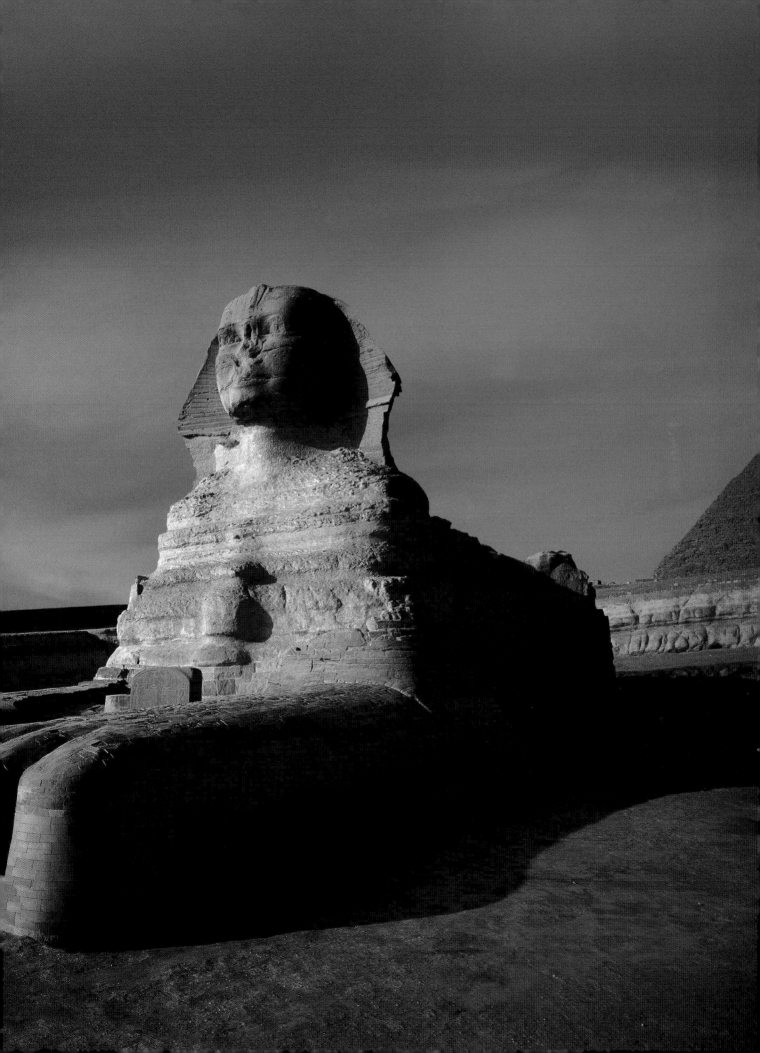

f your goal in combining two or more images is to simulate reality—or at least prevent a viewer from recognizing the manipulation—then it is important that you juxtapose photos that make sense together. For example, don't combine a shot taken on ISO 1600 film, which is very grainy, with a shot captured on ultrasharp, fine-grained film like Fujichrome Velvia or Ektachrome 100VS. Similarly, it's not a good idea to combine a 35mm picture with an image taken on medium or large format film.

If one of the photographs in the final composite was taken in the golden light of sunset while another component was taken with electronic flash, the result will look silly. If you want to create surreal, unrealistic montagelike effects, however, then you need not be so critical in choosing components. But to give the impression that the elements belong together, you must pay attention to all the details. These include the angle of illumination and direction of shadows, the color of the light, the sharpness of each component, the relative size of each element and the type of lens used for each original photo.

In removing each component from its background, I find a Wacom tablet an invaluable tool (http://www.wacom.com). This replaces the mouse. Instead of sliding a mouse over a pad, I use a special pen on a tablet that moves the cursor. The Wacom pen provides much more control in using the various tools in the tool palette, particularly the pen tool when cutting along the edge of a subject. It takes only a short time to become accustomed to the feel of the tablet and pen, and once you are comfortable with it, you'll never go back to a mouse. For the precise movements required in the complex manipulation of photographs, I highly recommend it.

strategies in
combining images

Making an Image Using Both Photoshop and Painter

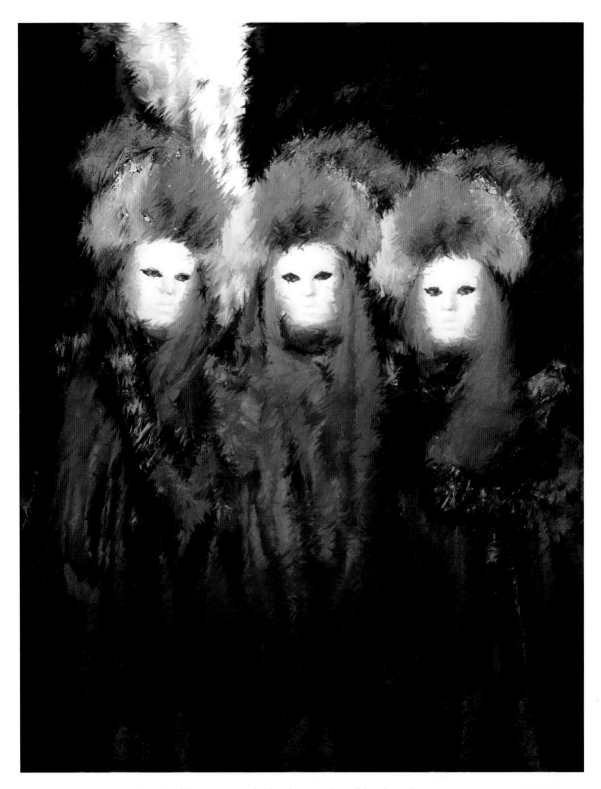

Several of the images in this book were created by going back and forth between Photoshop and Painter. This shot of Carnival in Venice was made the same way. In Painter, I used the brush **Flemish rub** to abstract the original to look like a painting. I used small brush strokes to prevent the picture from becoming too abstract and losing its definition. Then, in Photoshop, I used **Hue/saturation: levels** under the pull-down menu and **Image: adjust** to manipulate the color and contrast.

Mamiya RZ 67, 50mm wide angle, 1/60, f/4.5, Fujichrome Velvia, tripod.

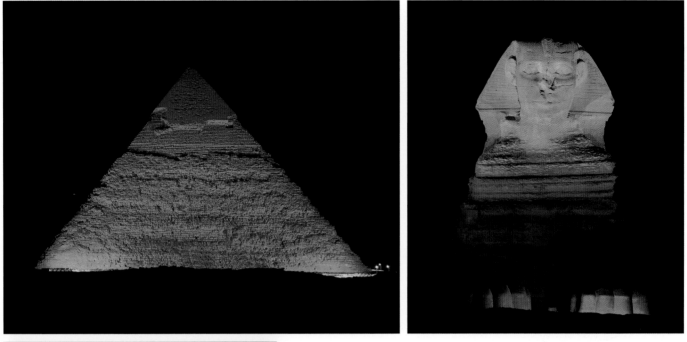

This juxtaposition of the sphinx with the Great Pyramid of Cheops is exactly as it actually occurs. However, during the nightly sound and light show, I wasn't permitted to stand where I could get the shot. Tourists were restricted to the seats, which were off to one side. In addition, the lights that illuminated the ancient structures were constantly changing. Rarely did they light both the sphinx and the pyramid simultaneously, and when they did, it was only for a few seconds. Therefore, I photographed the structures separately from across the street and assembled the composite with Photoshop.

Whenever a solid background is behind the subject, it is easy to separate that subject from the solid color behind it. Using the **magic wand tool**, I clicked on the black and then chose **Select: inverse** to select everything except the black background. The sphinx was now selected; however, there was a problem. Some of

the shadows on the top of the sphinx's head blended with the background, and they were not included in the selection. So, using the **lasso tool**, I added some of these areas back into the selection of the sphinx by holding down the shift key as I added each small area. I did this after I magnified the image 100 percent with the **magnify tool**.

Next, I copied the sphinx to the clipboard with **Edit: copy** and pasted it into the shot of the pyramid with **Edit: paste**. Using the **move tool**, I moved it into place and flattened the image with **Layer: flatten image**.

I now had a horizontal image. Using the pull-down menu **Image: canvas size**, I typed new pixel dimensions in the width and height boxes of the dialog box to give me a vertical picture. (The original dimensions were 3,352 high and 4,190 wide. The new dimensions gave me the exact same proportions but vertical: 4,190 wide by 5,237 wide.)

In the tic-tac-toe grid, I clicked the bottom center box. This told Photoshop to put the new vertical area *above* the existing picture.

When I clicked OK, the background color in the tools palette filled the sky above the sphinx and pyramid. I had previously selected black, so the night sky now rose vertically above the composite. In **Image: image size**, I resized the image from its present 63 megs down to 40 megs with the final pixel dimensions of 3,352 x 4,190.

The final touch was pasting the stars and the moon into the sky. The "star" photo (opposite page, middle left) was a shot of glitter sprinkled on black velvet and photographed with a star filter. I selected the black sky using the **magic wand tool** and then copied the shot of the stars to the clipboard with **Edit: copy**. I then pasted it into the selection of the black sky. Finally, I did the same with the moon.

All images Mamiya RZ 67 II, 350mm APO telephoto, Fujichrome Velvia, tripod; Sphinx and Great Pyramid: 2 seconds, f/5.6; Stars: 1/2, f/8; Moon: 1/8, f/5.6.

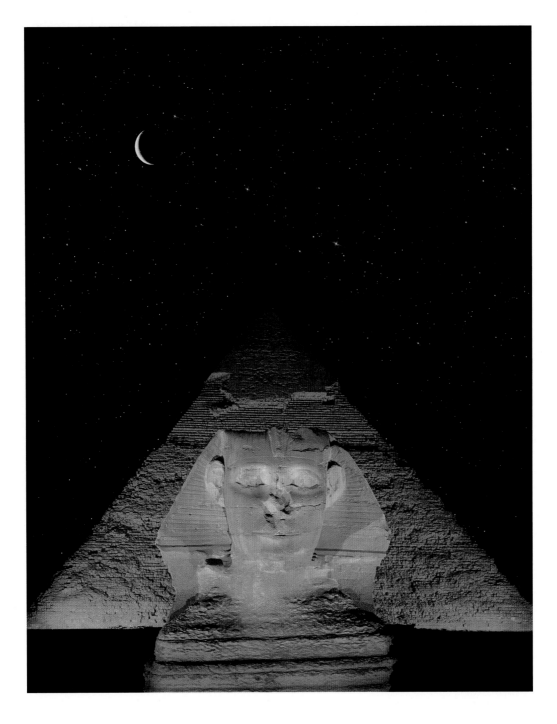

PUTTING A NEW SPIN ON CLASSIC SHOTS

You normally see the Taj Mahal photographed with a boring blue sky and many tourists in front of it. I decided to do something different.

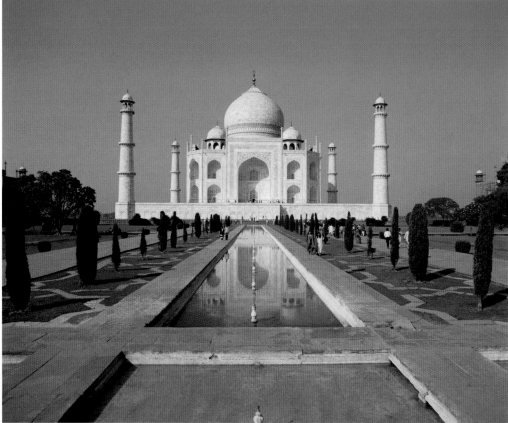

I used the wide-angle shot of the Taj as my background into which I placed the other components. I first placed a group of Indian women. I cut them out of their environment with the **pen tool**. When the entire periphery was defined, I went to the **layers/channels/paths palette** and clicked on **paths**. With the pull-down menu in this palette, I chose **make selection**, typed one pixel into the dialog box and hit OK. This turned the path into a selection. I then copied the group of women to the clipboard (**Edit: copy**) and pasted it into the background photo (**Edit: paste**). With the **move tool** in the tools palette, I moved it into place. The women were disproportionately large, so I used **Edit: transform: scale** to reduce them in size. I grabbed one of the corners of the box that appeared around the women and pulled inward (holding the shift key down to maintain the same proportion) to reduce the women until they were correctly sized.

Next I opened the rainbow picture, selected the entire image (**Edit: all**) and copied it to the clipboard. I then selected the sky in the Taj photo with the **magic wand tool**. I had to add to this selection those portions of the sky seen inside the arches of the minarets. I did this by holding down the shift key and clicking on these areas again with the **magic wand tool**. Once I had my entire selection, I expanded the selection (**Select: modify: expand**) by typing "one pixel" in the dialog box. This moves the selection outward by one pixel so when the rainbow is pasted into

the background, all of the blue pixels in the original sky will be replaced. This ensures that there won't be a faint blue line around the border of the new sky.

I then chose **Edit: paste into**, to replace the blue sky with the rainbow. With the **move tool**, I

moved the rainbow image until I was satisfied. I then flattened the layers with **Layer: flatten image**.

Finally, I selected the turquoise sari (with the **pen tool**) that one of the women was wearing and, using **hue/saturation**, I changed the color.

All photos Mamiya RZ 67 II, Fujichrome Velvia, tripod. Taj Mahal: 50mm normal lens, 1/15, f/22; Women: 50mm wide angle, 1/60, f/11-16; Rainbow: 250mm telephoto, 1/250, f/4.5.

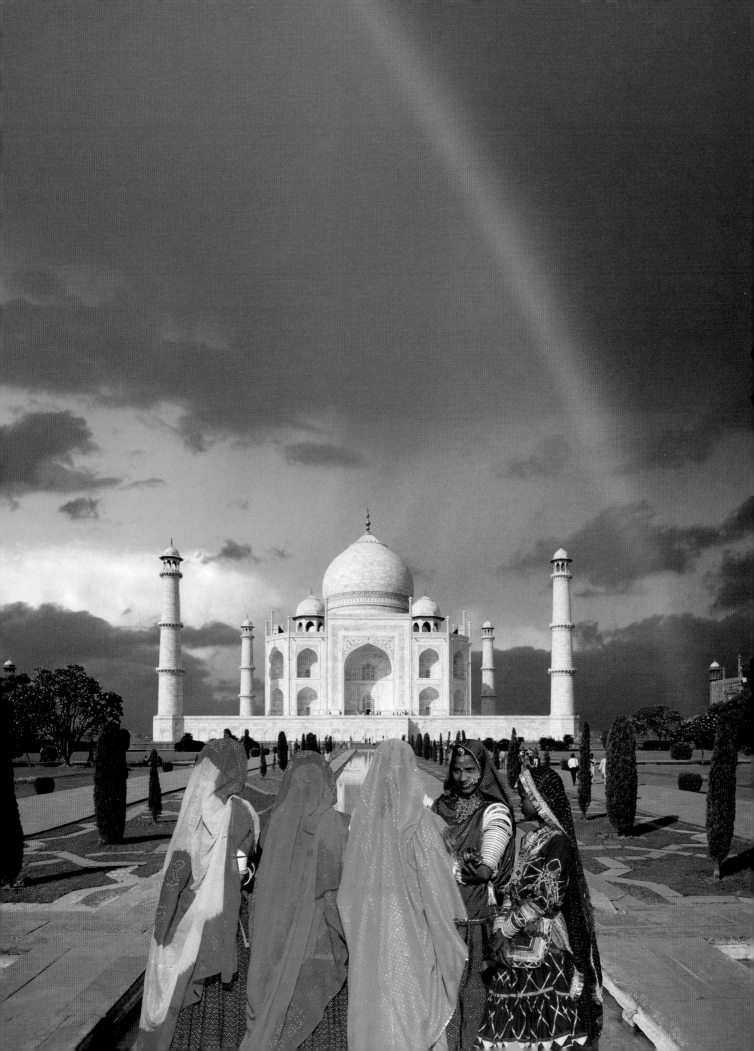

MERGING SUBJECTS WITH LANDSCAPES

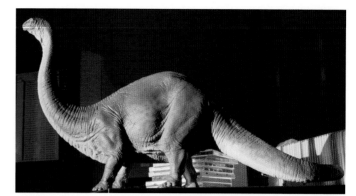

To put a dinosaur into a landscape and make it look like it belongs there requires special attention to lighting. Notice in this picture how the shading on the extinct reptile matches the glow on the surrounding rocks.

I photographed the dinosaur model (top right) on my desk using sunlight coming in from a window. I cut it out with the **pen tool** and made a selection with **make selection** in the pull-down menu of the **layers/channels/paths palette**. I saved this selection by choosing **Select: save selection** so I could easily use this component again in the future. I then copied the selection to the clipboard with **Edit: copy**.

Next, I decided exactly where I wanted the dinosaur in the shot of the Oregon coast (middle right). I selected a rock using the **pen tool** and then chose **Select: inverse** to select everything in the frame except the rock. I then hit **Edit: paste into** to place the model into the background. With **Edit: transform: scale** (which puts a box around the dinosaur), I held the shift key down to maintain the correct proportion and reduced the size of the dinosaur until I liked it. The dinosaur always remained behind the rock because the selection it was placed into excluded the rock itself.

My final step was to match the lighting. I took two color samples with the **eye dropper tool** in the **tools palette**. First I chose a darker color of brown, and then, holding down the **option key**, I chose a lighter tone. I could now see the two colors in

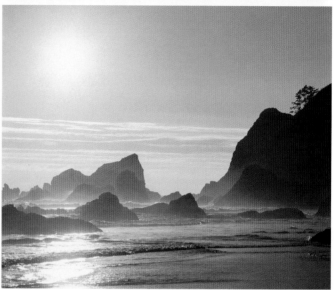

the foreground and background boxes, respectively, in the tools palette. I turned the dinosaur layer into a selection by holding down the **command key** and clicking on the dinosaur layer in the **layers palette**. I then clicked on the **gradient tool** in the tools palette. Using my Wacom pen (you can also use a mouse), I drew a line from the top of the dinosaur to the bottom of the feet. This created a color gradient. The colors that composed the gradient were taken from the foreground to the background color boxes.

All photos Mamiya RZ 67 II, Fujichrome Velvia, tripod. Dinosaur: 110mm normal lens, 1/15, f/16; Coastline: 250mm telephoto, 1/30, f/16.

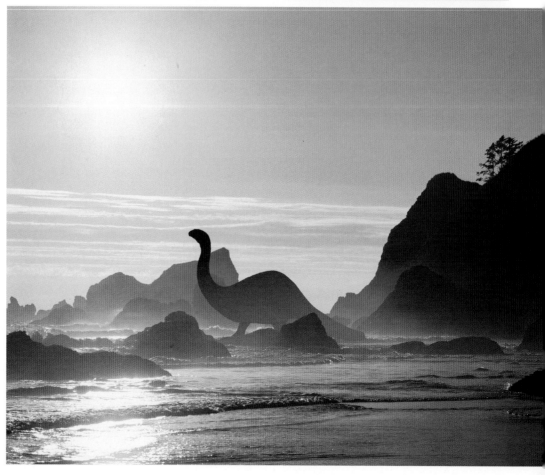

RESIZING SUBJECTS TO FIT NEW SURROUNDINGS

I separated the young Jordanian girl (near right) with the **pen tool**, creating a selection as described on page 40. I then copied the selection was to the clipboard.

Next I opened the shot of the window taken in Petra, Jordan (far right), and, using the **magic wand tool**, selected the dark space in the window. With **Edit: paste into**, I pasted the girl into the window. I then reduced her in size to fit appropriately with **Edit: transform: scale**. I held down the shift key to maintain the correct proportion and with my Wacom pen, I pulled one corner of the box around the girl to a smaller size.

All photos Mamiya RZ 67 II, Fujichrome Provia 100, tripod. Girl: 250mm telephoto, 1/30, f/4.5; Windows: 1/2, f/22.

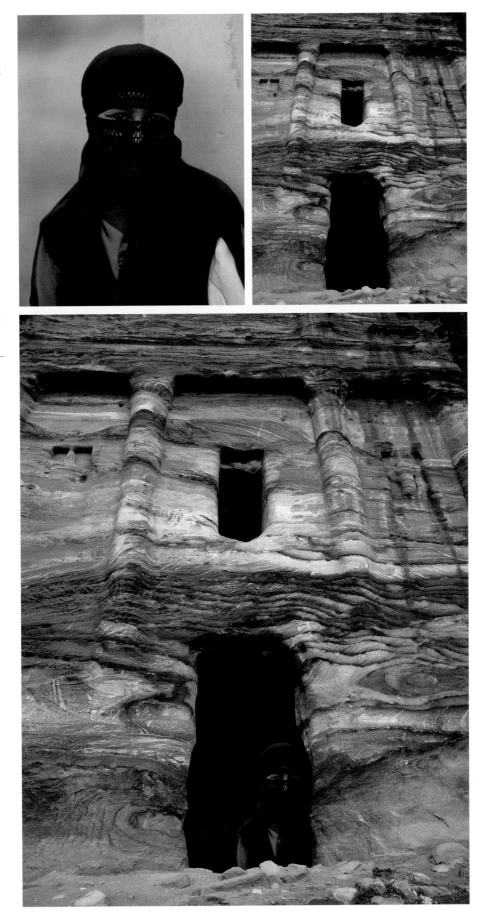

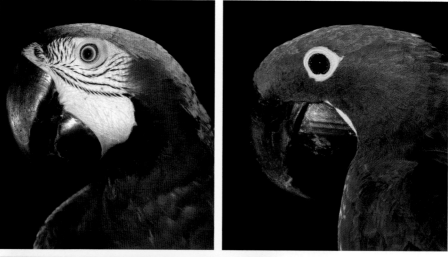

Separating these macaws from their backgrounds was a bit problematic; because part of their beaks are dark, the magic wand tool might grab those parts along with the black background. However, since the backgrounds are monochromatic, I was able to separate the macaws from the backgrounds by adjusting the tolerance of the **magic wand tool** to zero (just double-click on the magic wand tool and the dialog box opens where you can type in the tolerance value). Now, I could select the black background in both shots without including the shadowed parts of the beaks.

First, I selected the scarlet macaw by selecting its background and clicking **Select: inverse**. This selected the bird, or everything except the background. I then used **Select: modify: contract** and chose one pixel in the dialog box. This contracted the selection by one pixel, which eliminated the possibility of even a tiny amount of black being taken from the background. I then pasted the macaw to the clipboard and pasted it into the photo of out-of-focus foliage (middle right). I moved the bird into place and repeated the same procedure for the blue macaw.

All photos Mamiya RZ 67 II, Fujichrome Provia, tripod. Macaws: 250mm telephoto, f/8, Metz 45 flash; Foliage: 500mm APO telephoto, 1/30, f/6.

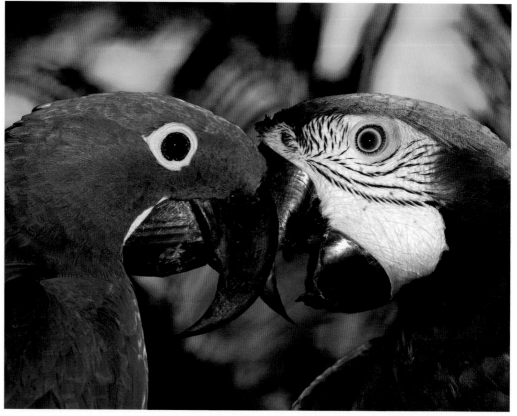

CHANGING DETAILS TO ADD REALISM

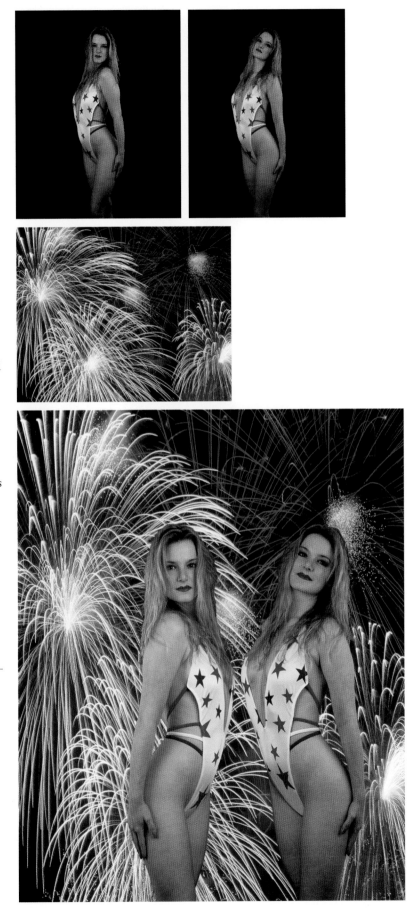

My goal for the final image was to suggest that I had photographed twin models. Of course, I really took two pictures of the same model in two different poses (near right and far right). I didn't want the pattern of the bathing suits to be identical, since this would be unlikely, so I digitally rearranged the red and blue stars.

I selected both poses of the model the same way. I used the **magic wand tool** to select the black background, then used **Select: inverse** to capture the model while eliminating the background. With **Select: modify: contract**, I chose one pixel in the dialog box to constrict the selection by one pixel and eliminate any of the black background at the edge of the model. Then, I pasted the poses into the fireworks shot (middle right) and moved them into place with the **move tool**. I then flattened the layers with **Layers: flatten**.

Next, I moved individual stars in each bathing suit by selecting a star with the **magic wand tool** and moving it with the **move tool**. In addition, I changed the size of a couple of them using **Edit: transform: scale**. After I moved a star, I used the **clone tool** (also called the rubber stamp tool) to fill the area where the star had been.

All photos Mamiya RZ 67 II, Fujichrome Velvia, tripod. Model: 110mm normal lens, Speedotron Power Pack with two flash heads, f/16; Fireworks: 250mm telephoto, 2 seconds, f/8.

RE-CREATING ELEMENTS NOT IN THE FRAME

When I took the original photo of this io moth (above), one of the wing tips was out of the frame. To repair this error, I enlarged the photo to 200 percent and used the **pen tool** to outline the other wing tip. Once I converted this small path to a selection (in the layers/channels/paths palette I clicked on "path" and in the pull-down menu I chose **make selection**). I then copied it to the clipboard using **Edit: paste**.

Next, I had to widen the photograph to accommodate the extended wing. I went to **Image: canvas size** and added 100 pixels in the width dimension. To keep the shot roughly proportional, I also added 100 pixels to the height dimension. In the tic-tac-toe grid, I clicked on the middle right box, which tells Photoshop that the new area to be added will be on the left. I clicked OK, and the background color now comprised the new area on the left of the frame.

I then used the **clone tool** to copy bark from the photograph over the new areas. Next, I pasted the wing tip from the clipboard into the picture with **Edit: paste** and then flipped it with **Edit: transform: flip horizontal**. With **Edit: transform: rotate**, I rotated the wing tip (the cursor must be outside the box that forms around the layer to rotate it) until the orientation was correct. Using the **move tool**, I then moved it into position. Finally, I used the **clone tool** to alter the color a bit in one of the wing tips so they were slightly different from each other, and then I flattened the image with **Layer: flatten**.

Mamiya RZ 67 II, 110mm lens, 1/8, f/11, Fujichrome Velvia, tripod.

Inverting Background and Foreground

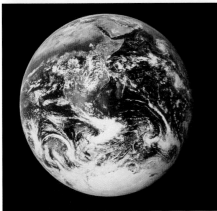

I obtained the image of the Earth (bottom left) from the Johnson Space Center in Houston, Texas. It is in the public domain and available to everyone without charge.

I took the picture of Death Valley, California (top left), with a fish-eye lens (37mm on the Mamiya RZ 67), which accounts for the curvature of the horizon. I used the **pen tool** to outline an area of hardened salt and then converted the path to a selection in the **layers/channels/paths palette** by using the pull-down menu and choosing **make selection**. I saved the selection with **Select: save selection**.

I then opened the image of the stars (middle right: glitter on black velvet, photographed with a star filter), copied it to the clipboard and pasted it into the selection with **Edit: paste into**. I flattened the layer with **Layer: flatten image**. I then opened the image of the Earth, separated it from its black background and copied it to the clipboard. Using **Select: load selection**, I recalled the selection in the salt and then pasted the Earth into it. I reduced the size of the Earth with **Edit: transform: scale**. A box formed around the Earth image, and by holding the shift key down while I grabbed a corner of the box, I kept the correct proportion of the globe as it got smaller. I clicked OK and flattened the layer.

All photos Mamiya RZ 67, Fujichrome Velvia, tripod. Stars: 110mm lens, f/16, Metz 45 flash; Death Valley: 37mm fish-eye, 1/60, f/8.

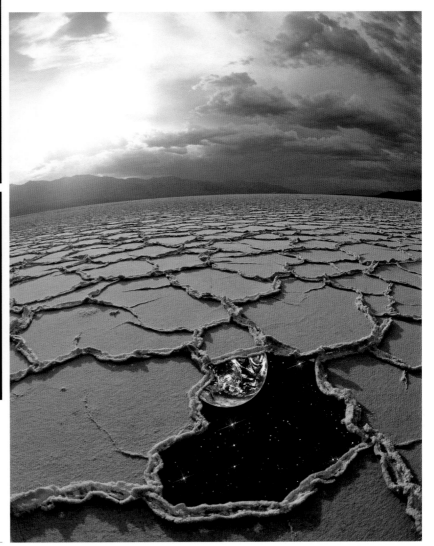

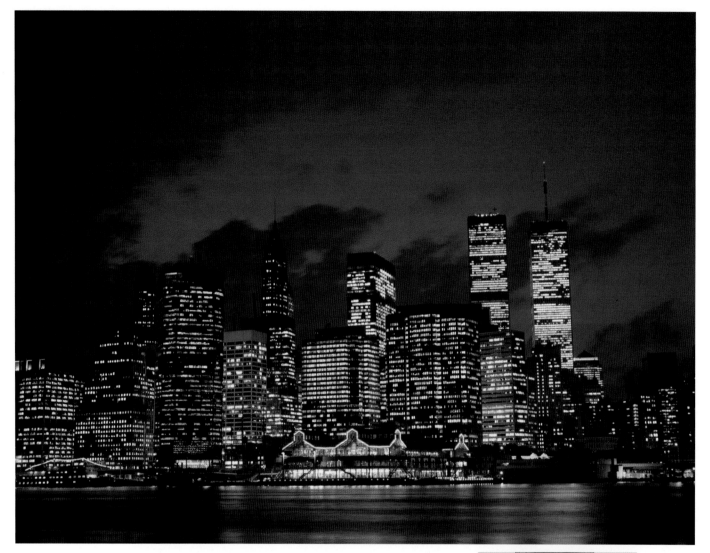

I placed the two lightning images (opposite page, top) behind New York by separating the entire skyline from the clouds with the **pen tool**. Next I copied one of the images of lightning to the clipboard with **Edit: copy** and pasted it into the selected sky with **Edit: paste**. I did the same for the second picture of lightning and then used the **clone tool** to blend together the borders of each shot. I then flattened the layers with **Layer: flatten image**.

I added the model's legs (near right) by using the **pen tool** again to cut out the model and paste the legs into the background cityscape. Once I outlined the legs, I converted the path to a selection with **make selection**, a pull-down menu option in the **layers/channels/ paths palette**. I copied it to the clipboard and superimposed it over the city with **Edit: paste**.

However, the distance from the model's thighs to her shoes wasn't sufficient to extend from the top to the bottom of the horizontal composition of the skyline. Therefore, I used **Edit: transform: scale** and, without holding the shift key down (which would have maintained the proper proportions), I stretched the legs upward.

As a final touch, I used the **burn/dodge tool** in the burn mode to put in shadows under the shoes.

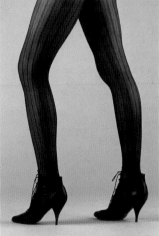

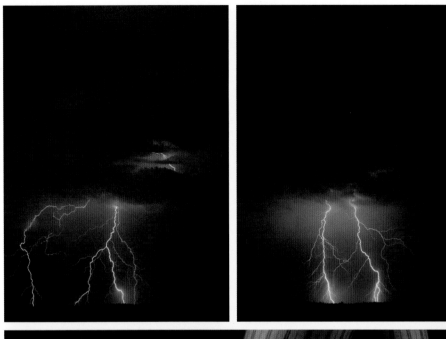

All photos Mamiya RZ 67, Fujichrome Velvia, tripod. New York: 250mm telephoto, 10 seconds, f/5.6; Model: 110mm normal lens, f/16, Speedotron Power Pack with two flash heads; Lightning photos: 250mm telephoto, shutter open until lightning flashed, f/5.6.

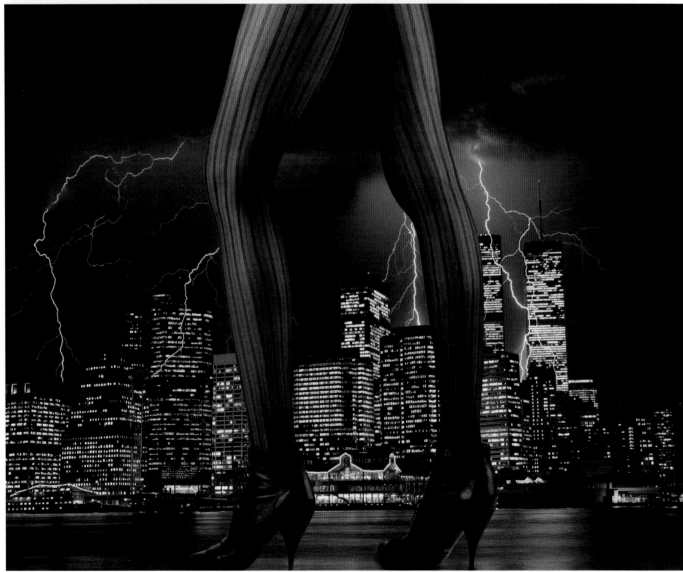

LOWERING OPACITY WHEN MERGING IMAGES

I did this composite in two steps. First I combined the lightning (right) with the stars, shown on page 69, then composited the lightning/stars with the model.

I copied the image of the stars to the clipboard and pasted it over the lightning image. In the **layers palette**, I chose **lighten** in the pull-down menu that determines how the two layers are combined. I then flattened the image with **Layers: flatten**.

I copied the model (below), whom I photographed standing on a box for additional height, onto the clipboard. Then I past-ed the model into the lightning/ star image and resized her smaller with **Edit: transform: scale**. I moved her into place with the **move tool** and changed the opacity of the layer containing the model to 75 percent in the **layers palette**.

Both photos Mamiya RZ 67, Fujichrome Velvia, tripod. Lightning: 250mm telephoto, shutter open until lightning flashed, f/5.6; Model: 110mm normal lens, f/16, Speedotron Power Pack with two flash heads and two Photoflex soft-boxes.

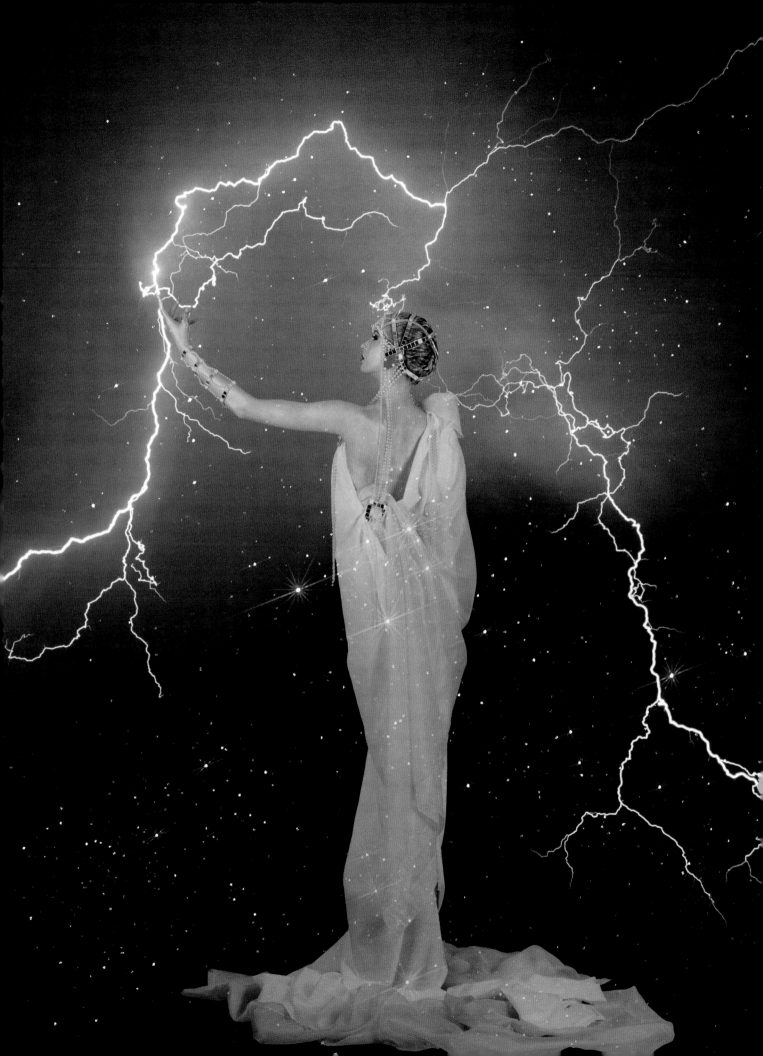

advanced
manipulations

chapter | **FIVE**

earning Photoshop is like studying a foreign language. At first, you mentally translate from English into the other language. Later, you can actually think in the new language. The same is true when you manipulate photographs with Photoshop. In the beginning, you know what you want to accomplish and you stumble around the many tools and pull-down menus, trying to make the program do what you want. After a while, you can look at a photograph and see in your mind's eye all the various ways you can mold it into your visual concept.

I chose the images in this chapter so I could delve into techniques that will expand your understanding of Photoshop. I made all of these shots by combining several techniques, and in many instances, the final picture is very different from the original. From these pictures I hope you will appreciate the remarkable ability of this program to create practically any type of picture you imagine.

advanced manipulations

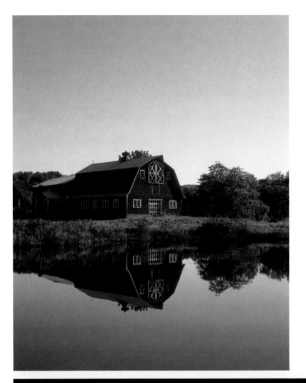

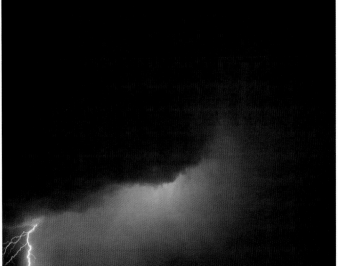

When the movie *Twister* came out, my stock photo agency asked me if I could make a photograph of a tornado. I wasn't sure if I could do this, but I went home and looked through my stock photos and decided I'd give it a try.

The background for my composite was a barn I'd photographed in Vermont in the early morning light (top). I selected the sky with the **magic wand tool**, and then used **Select: modify: ex-**

Both photos Mamiya RZ 67 II, Fujichrome Velvia, tripod. Barn: 110mm normal lens, 1/8, f/22; Storm cloud: shutter open until lightning flashed, f/5.6.

pand to expand the selection by one pixel to eliminate any residual blue pixels from the sky at the edge of the selection. Next I opened a second shot I'd taken during a lightning storm in Arizona (above). I copied the entire photo to the clipboard with

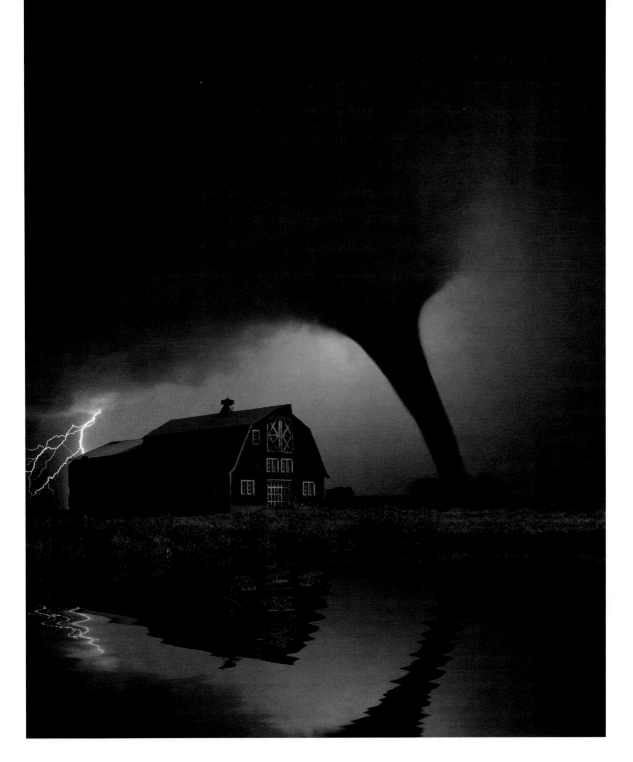

Edit: all and **Edit: copy**, and then I created a layer of the stormy sky above the barn with **Edit: paste into**. With the **move tool**, I positioned it as you see it here.

Next, I clicked on the background layer (the barn photo) in the **layers palette**, which allowed me to work only on that layer. Using the color balance and levels dialog boxes (**Image: adjust: color balance** and **Image: adjust: levels**), I darkened the picture and changed its color to match the dark brooding sky.

I flattened the image with **Layer: flatten image**. To make the funnel, I used the clone tool. First, however, I clicked on the **lasso tool** to draw the shape of the twister. I feathered this selection (**Select: feather**) with a twenty-pixel feather radius to soften the edge of the "swirling air." Then, with the **clone tool**, I copied portions of the dark cloud down into the funnel until I liked the tonality. At the bottom of the funnel, I also used the clone tool—but this time with 90 percent opacity—to create a dust cloud.

I then selected the entire sky and barn (again with the **lasso tool**) and copied it to the clipboard with **Edit: copy**. I deselected the upper portion of the picture (**Select: deselect**) and then selected the pond with the **lasso tool** and feathered the selection ten pixels with **Select: feather**. I pasted the clipboard image into the pond by clicking **Edit: paste into** and then used **Edit: transform: flip vertical** to flip only the new layer. I moved the "reflection" into place with the **move tool**, and then applied the wave filter—**Filter: distort: wave**—twice until I liked the rippling water effect. In the dialog box of the wave filter, I clicked the "sine" box.

MASTERING ABSTRACT CREATIONS

Omni Magazine used the image at far right a few years ago as a cover shot that tied in to the lead story titled, "What Would You Say to an Alien?"

I originally photographed the mannequin head against white to make it easy to separate from its background (near right). I chose the **magic wand tool** and clicked on the white color, then hit **Select: inverse** to select only the mannequin head. With **Select: modify: contract**, I reduced the selection by one pixel to eliminate any vestige of the white background. I copied this to the clipboard with **Edit: copy** and pasted it into the image of clouds (bottom right) with **Edit: paste**. I moved it into place with the **move tool**. In **Image: adjust: hue/saturation**, I changed the color to red. To create a clone of the mannequin head, I hit **Edit: paste** again and created another layer of the same mannequin. I flipped the image with **Edit: transform: flip horizontal** and moved it into place with the move tool. I changed the color of this layer to match the other mannequin. Then I flattened all the layers with **Layer: flatten image**.

The bubble was a challenge. I wanted the faces to reflect in the surface of the bubble as they would if all four components—the two mannequins, the bubble

and the clouds—were actually juxtaposed as you see them here.

To accomplish this, I first used the **circular marquee tool** to draw an oval between the two faces. With **Select: save selection** I saved the oval, then deselected it with **Select: deselect**.

I drew a large circle, not an oval, with the same tool (circular marquee), but this time I included everything I wanted reflecting in the bubble. My circle included a portion of each red face. I copied the circular selection to the clipboard with **Edit: copy** and deselected the circular selection.

Next I clicked **Select: load selection** to replace the oval between the faces. With **Edit: paste into**, I inserted the circular selection from the clipboard into the oval, but it was much too big to fit. With **Edit: transform: scale**, I grabbed the corners of the box that forms around the larger picture and moved them toward the center of the oval until I could see the mannequin faces. I clicked OK and used **Filter: distort: spherize**, which appropriately distorted the image within the oval.

And finally, I chose **Image: adjust: levels** and lightened the oval to my satisfaction. Then I flattened the layers with **Layer: flatten image** to reduce the file size for storage.

Both photos Mamiya RZ 67, Fujichrome Velvia, tripod. Mannequin: 110mm lens, Speedotron Power Pack with one strobe head, f/16; Clouds: 250mm telephoto, 1/250, f/4.5, handheld from a boat.

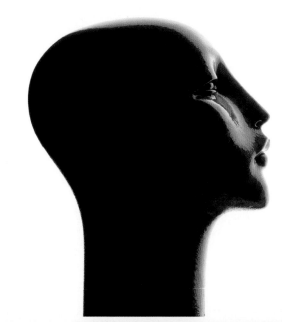

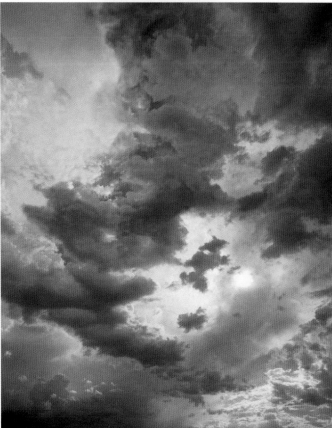

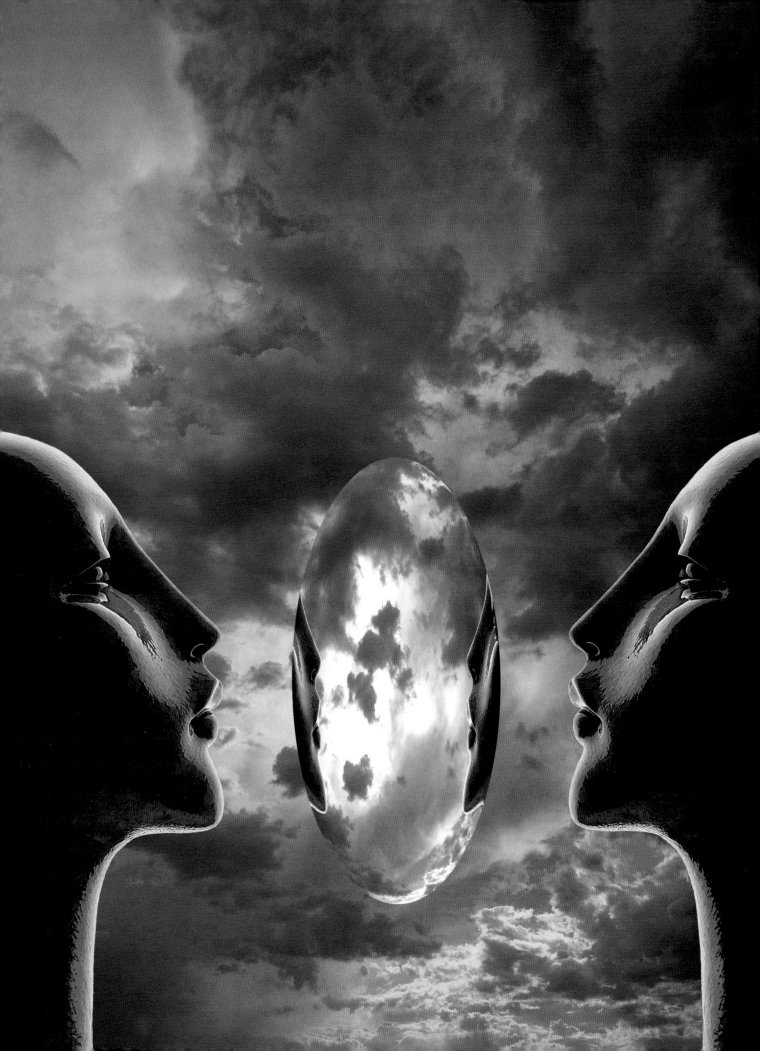

Burning and Dodging for Convincing Composites

I spent about thirty minutes painstakingly outlining this young Balinese dancer (near right) with the **pen tool** to create a path. Then I changed the path into a selection by choosing **make selection** in the paths palette. To make sure none of the background was included in the selection, I hit **Select: modify: contract** and in the dialog box chose "one pixel." This caused the selection to shrink by one pixel, which eliminated traces of color from the background within the selection. I then copied the dancer to the clipboard using **Edit: copy**.

Next, I opened the background photo of a stairway leading to a temple in the Balinese jungle (bottom left). I clicked **Edit: paste** to insert the dancer, and with **Edit: transform: scale**, I reduced the size of the young girl until her proportions were correct. With the **move tool**, I moved her into place on the step (bottom right).

Unless the shadows under the dancer's feet looked correct, the composite wouldn't work. Therefore, I spent much time creating shadows that appeared natural. I used the **burn/dodge tool** to darken the appropriate areas, including subtle changes in the side of the dancer away from the direction of the light. Using a brush size with soft edges, I darkened one side of the face and the left side of the costume. I then saved the picture as a new file with **File: save as**.

To go one step further, I created the image at far right by applying **Filter: blur: Gaussian glow**. Then I used **Filter: sketch: Bas Relief** and copied the result to the clipboard. I clicked **File: revert** to bring the image back to the original composite. I hit **Edit: paste** to paste the Bas Relief–filtered version over the original, and then, in the **layers palette**, I chose "darken" in the pull-down menu. Finally, I flattened the picture with **Layer: flatten image**.

Both photos: Fujichrome Provia 100F, tripod. Dancer: Mamiya RZ 67 II, 250mm telephoto, 1/125, f/5.6; Jungle: Mamiya 7, 45mm wide angle, 2 seconds, f/22.

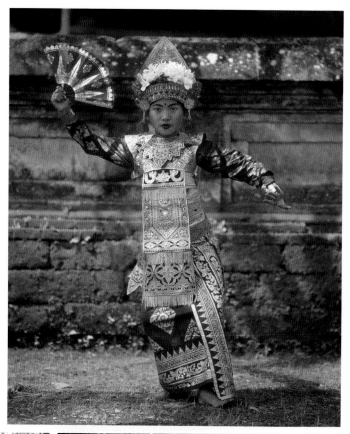

PLACING BACKGROUND DETAILS IN FRONT OF SUBJECTS

When I photographed this albino cobra in a terrarium (bottom left), I knew I would digitally place it in a jungle environment. However, I didn't have a shot with only jungle vegetation from a low angle, so I used this picture of an ocelot kitten (below left). With the **clone tool**, I eliminated the cat.

I photographed the cobra with a flash, as I did with the jungle foliage, so the two pictures would work together well. However, the reflections on the snakeskin were distracting, so I used the **clone tool** again to eliminate them.

To separate the cobra from its background, I used the **magic wand tool**, clicked the white background and then hit **Select: inverse** to select everything except the background—in other words, the snake. I shrunk the selection by one pixel with **Select: modify: contract** and copied it to the clipboard with **Edit: copy**. I activated the jungle picture by clicking on it, and then I pasted the cobra into it with **Edit: paste**.

The key to making this a successful composite to suggest that the cobra was not just pasted in front of the foliage, but that it was really in and among the blades of grass and leaves that composed the background. Therefore, I spent about an hour selecting individual pieces of vegetation with the **pen tool**, copying them to the clipboard (Edit: copy), pasting them into the picture (Edit: paste) and them moving them (move tool) in front of various parts of the snake's body. With **Edit: transform: flip horizontal** and **Edit: transform: rotate**, I reoriented these small pieces so they wouldn't resemble the original pieces of foliage that they came from.

Finally, I used the **burn/dodge tool** to add a shadow behind the cobra (below right).

A note about making precise selections: Instead of using the pen tool, I sometimes use the lasso tool. With the image magnified 200 percent, I use the Wacom pen and the lasso tool to select small portions of an image. Depending on the complexity of the subject, you may find this to be a faster way to define a selected area.

Both photos Mamiya RZ 67 II, Fujichrome Provia 100, handheld. Ocelot: 350mm APO telephoto, f/8, Metz 45 flash; Cobra: 110mm normal lens, Metz 45 flash, f/8.

Adding Movement to Transported Figures

I put together the "Carnival in Venice" theme with a background I photographed in Venice, Italy (above), and a studio shot I made with a model wearing a Carnival costume (above right). I photographed the original shot of Venice through two Cokin filters—a blue filter and one that diffused the scene. I photographed the model against a blue background, and I created a path with the **pen tool**, then turned it into a selection by choosing **make selection** in the **paths palette**. I copied the selection to the clipboard and pasted it into the background with **Edit: paste**.

I wanted to suggest that the costumed Carnival participant was walking past the camera, so I used a motion blur to show some movement. Using **Filter: blur: motion blur**, I chose a zero angle (which defines the movement horizontally) and tried various amounts of movement until I liked one of them. Finally, with **Image: adjust: hue/saturation**, I altered the color and added a grain texture with **Filter: noise: add noise**.

Both photos Mamiya RZ 67 II, Fujichrome Velvia, tripod. Venice: 350mm APO telephoto, 1/15, f/5.6; Model: 110mm normal lens, f/16, Speedotron Power Pack with two flash heads and two Photoflex softboxes.

MANIPULATING ENTIRE FIGURES

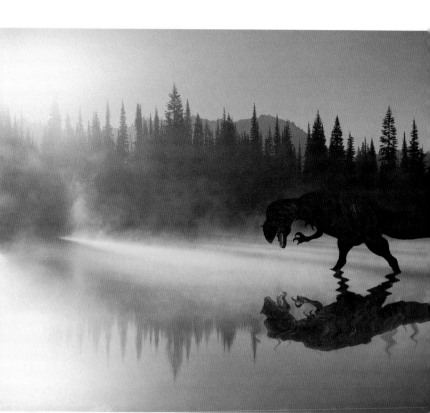

I took this museum display of a dinosaur (top left; also on page 54) with a harsh, on-camera flash, the only lighting I had available. The red railing blocked my view of the reptile's feet, but there was nothing I could do. I used the **pen tool** to create a path of the animal (excluding the feet, which I planned to hide under the surface of the water), and then in the **paths palette** I used the pull-down menu and chose **make selection**. I then copied the dinosaur to the clipboard with **Edit: copy**.

I opened the sunrise shot of Reflection Pond at the base of Mt. Rainier in Washington (above left) and clicked **Edit: paste** to insert the dinosaur into the scene. I used the **move tool** to place the animal where I wanted, then chose **Layer: new: adjustment layer**. This opened a dialog box were I could choose

Both photos Mamiya RZ 67 II, Fuji-chrome Velvia. Dinosaur: Metz 45 flash, f/5.6, handheld; Reflection pond: 250mm telephoto, 1/8, f/32, tripod.

an operation that only affected the dinosaur layer. I selected **color balance**. In the dialog box that opened, I made the animal more yellow and a bit red to match the sunrise colors on the pond. I clicked OK and then worked with the **clone tool** to eliminate the unattractive reflection of the flash in the skin. Then, still using the clone tool, I changed the opacity (by double-clicking on the clone tool, which brings up the **navigator palette**) to 20 percent and cloned some of the low-lying fog over the dinosaur's body to lower its contrast. I flattened the layer with **Layer: flatten image**.

My next step was to bend the

head downward. I did this in four different steps, each step the same as the previous. First I used the **lasso tool** to roughly select the head and neck of the animal. (I included a little of the background in my selection.) Then, with **Edit: transform: rotate**, I rotated the selection counterclockwise a bit. With the **move tool**, I moved the head-neck section back toward the body until the bottom edge of the section made contact. I filled in the gap that was then open from the rotation (it looked like a pie-shaped wedge) with the **clone tool**. In other words, I used adjacent skin to clone for the wedge. I repeated this procedure three more times until the head and neck were angled downward. The four rotations had disturbed the background next to the dinosaur's head and neck, so I fixed this with the **clone tool**. I examined

the altered area at 200 percent to make sure there were no telltale signs of digital manipulation.

Finally, I made the reflection. I selected the dinosaur again, this time with the **magic wand tool**. I copied it to the clipboard with **Edit: copy** and then pasted it into the scene with **Edit: paste**. With **Edit: transform: flip vertical** I flipped the layer upside down. Using the **move tool**, I placed the duplicate image with the feet of the reflection and the feet of the upright dinosaur touching. In the **layers palette**, I lowered the opacity of the reflection to 70 percent. I flattened the picture with **Layer: flatten image**. My last step was to create a ripple in the water. I selected a rough area of the reflected dinosaur, plus some of the water around it. Using **Filter: distort: wave**, I changed the wave parameters until I was satisfied with the result.

REBUILDING MISSING ELEMENTS FOR AN ABSTRACT IMAGE

I selected the ballerina using the **magic wand tool**, first clicking on the black leotard and then, holding the shift key down to add to my selection, I included the model's skin and hair (top right). The tips of her fingers, however, were hidden by the bar. I had to re-create her fingers later.

I opened the photo of the slot canyon in Arizona (middle right), and I decided I wanted to expand the image horizontally. I used **Image: canvas size** to give me a greater horizontal dimension. The original dimensions were 3,277 pixels wide by 4,096 pixels high, so I typed in 4,000 pixels for the width in the dialog box and kept the same height. In the tic-tac-toe box, the placement of the original image defaults to the center, so I moved it to the middle left box, leaving the new area to be added on the right. I clicked OK. The color that defined this new area was now whatever color was showing in the background box of the **tools palette**. I used white.

To fill in the new portion, I clicked on the white area with the **magic wand tool** and hit **Select: inverse** to select everything except the white area. I copied the image to the clipboard (**Edit: copy**) and then clicked **Select: inverse** again to re-select only the white portion. I pasted the photo into the new area with **Edit: paste into**. Next, I hit **Edit: transform: flip horizontal** to flip the layer such that, with the **move tool**, I could mate the two portions precisely. I flattened the photo with **Layer: flatten**.

Next, I distorted the background from its original proportions by choosing **Image: image size** and typing in the new horizontally oriented dimensions of 4,096 wide by 3,277 high. With **Image: adjust: hue/saturation**, I

changed the color scheme to blue.

I clicked on the photo of the ballerina to activate it, and with the model still selected, I copied her to the clipboard (**Edit: copy**). I clicked on the modified background picture and used **Edit: paste** to insert the dancer into the slot canyon. With the **move tool**, I moved her into place and then flattened the picture with **Layer: flatten image**.

To rebuild the fingers, I used the **clone tool** and, with the image magnified 300 percent, I slowly lengthened each finger by cloning the skin on the hand. The result isn't absolutely perfect, but it's close.

Finally, I used the **circular marquee tool** and selected an area around the ballerina. I lightened it slightly using **Image: adjust: layers** and then applied **Filter: distort: spherize** for the final effect.

Both photos Mamiya RZ 67 II, Fujichrome Velvia, tripod. Ballerina: 110mm lens, Speedotron Power Pack with two flash heads and two white umbrellas, f/11; Canyon: 250mm telephoto, 1/2, f/22.

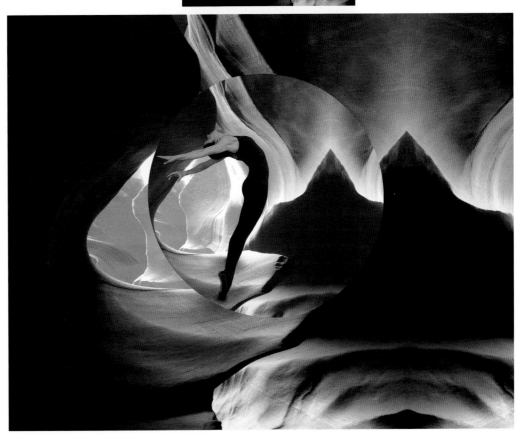

WRAPPING IMAGES AROUND 3-D SHAPES

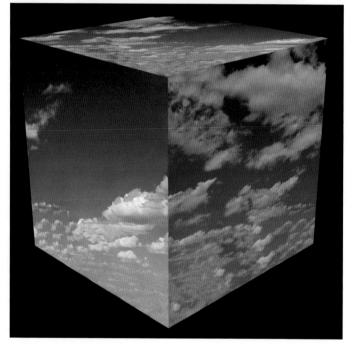

"Texture mapping" means wrapping a photograph around a graphic shape in a 3-D program. Photoshop can do this in a limited way; this image of a cube defined by clouds (opposite page) is an example.

First, I drew the shape of the cube using the **line tool** (left). I defined the thickness of the line by two pixels and simply made a cube by connecting lines. Next, I opened the shot of the clouds (top left) and selected portions of the picture for each facet of the cube. I copied each portion to the clipboard (**Edit: copy**), selected a panel of the cube with the **magic wand tool** and pasted the clouds in with **Edit: paste into**. After I pasted in all the panels, I wanted to eliminate the actual lines that defined the cube. I selected them with the **magic wand tool** and used the **clone tool** to extend the sky to cover the lines (above right).

I then selected the entire cube by first selecting the black background color and hitting **Select: inverse**. Using **Edit: transform: scale**, I stretched the cube horizontally to distort its shape. I

copied the new cube to the clipboard with **Edit: copy** and pasted it into a star field (glitter on black velvet, shot with a star filter). In the **layers palette**, I chose the pull-down menu option "lighten," which allowed the stars to show through the cube. My final step was to add the lens flare. I used **Filter: render: lens flare**, and in the dialog box that opened, I defined the amount of flare and its direction.

Sky with clouds: Mamiya RZ 67 II, 250mm telephoto, 1/250, f/5.6, Fujichrome Velvia, tripod.

DESIGNING A STYLIZED IMAGE FROM ONE SUBJECT

I used the **pen tool** to separate the zebra from its environment. As you can see, the feet of the animal were hidden in the grass, so there was nothing I could do to rebuild them (right). My intention, however, was to create a graphic image of a colorful zebra herd, and I knew I wouldn't need to include the feet.

Once I had selected the animal, I copied it to the clipboard (**Edit: paste**) and opened a new file using **File: new**. I pasted the zebra into the new space with **Edit: paste**, and turned the image into a high-contrast photo with **Image: adjust: levels**. I selected only the black stripes with the **magic wand tool** and filled the selection with red. To do this, I clicked on the foreground color box in the **tools palette** and chose red in the dialog box. Then, with all the black stripes selected, I held down the option key and hit the delete key. Red now replaced all the black (below right).

Next I copied the red zebra to the clipboard and pasted it into a new file (**File: new**). With the option key held down and the **move tool** highlighted, I could drag a copy of the zebra anywhere I wanted. Every time I disengaged the Wacom pen from the tablet (or, if you are using a mouse, every time you click, drag and release) Photoshop cloned a copy of the zebra to another location. You could do this until the entire frame was filled with red zebras.

Using the **magic wand tool**, I selected only the red in the picture. In the foreground color box in the **tools palette**, I chose green, while the background box was red. Then, using the **gradient tool** in the **tools palette**, I dragged a line from the upper left corner to the lower right. This resulted in the gradual

change from green to red in the zebra's stripes (opposite page). To soften the image, I applied **Filter: blur: KPT Gaussian glow**.

Zebra: Mamiya RZ 67 II, 500mm APO telephoto, 1/250, f/8, Fujichrome Provia 100, camera rested on beanbag in Land Rover.

Separating Fine Details

I had this photo of the endangered clouded leopard for years, but I couldn't use it because the plywood background was terrible (right). The background needed replacing, but until recently it was extremely difficult to separate fine hairs and whiskers from a background. The problem is that each hair is not a single color. And even more significant, each hair is not a single opacity. The center of a hair is opaque; you cannot see any of the background color through this portion. But the edges of each strand are in fact less opaque. When the image is magnified about 200 percent on your monitor (or if you use a powerful loupe), you can see background colors showing through the hair.

Another problem is with out-of-focus elements in the composition. As depth of field falls off (say with a portrait), and the edges of the head and strands of hair become soft, the conventional technique of cutting around those edges creates a hard line. Even the feathering and blurring techniques in Photoshop that attempt to retain the soft, out-of-focus transition zone don't produce convincingly real compositions.

I used the Corel KnockOut program to composite this picture. The strategy that KnockOut uses to separate a difficult subject from its environment is ingenious. You use two selection tools in the **tools palette**—the **inside object tool** and the **outside object tool**. The latter defines the colors in the background immediately outside the edge of the subject. This tells the computer to eliminate this portion of the picture. A dashed line shows you what this selec-

tion looks like. The inside object tool defines a similar path around the border of the subject, but this time it is within the subject itself. This tells the computer what colors are included in the subject. When KnockOut processes the difference between the two selections, the subject is effectively isolated from the background and ready to be combined with a new one.

For problem areas, such as when the edge of the subject is very close in color to the background (such as when dark-green foliage meets the dark-brown hair of a cat), Knockout provides additional tools to help the computer decide which is the subject and which is the background. You can use the **injection tool**, for example, to retain colors in the subject that might otherwise be lost. Using this tool, I simply clicked on brown hairs at the edge of the head. The **tweezers** tell the computer to identify specific areas in the image as background, such as out-of-focus foliage seen through a tangle of hair on the top or side of someone's head.

Using these tools, I created a mask around the leopard. I pasted the out-of-focus foliage into the background selection, just as you do in Photoshop, and the perfect result is evidenced on the opposite page.

The last thing I changed was the shadow on the tongue. I used the **clone tool** from the **tools palette** to clone pink areas of the tongue over the darker shadow.

Both photos Mamiya RZ 67. Foliage: 250mm telephoto, 1/30, f/5.6, Fujichrome Velvia, tripod; Leopard: Metz 60 flash, f/16, Ektachrome 64, handheld.

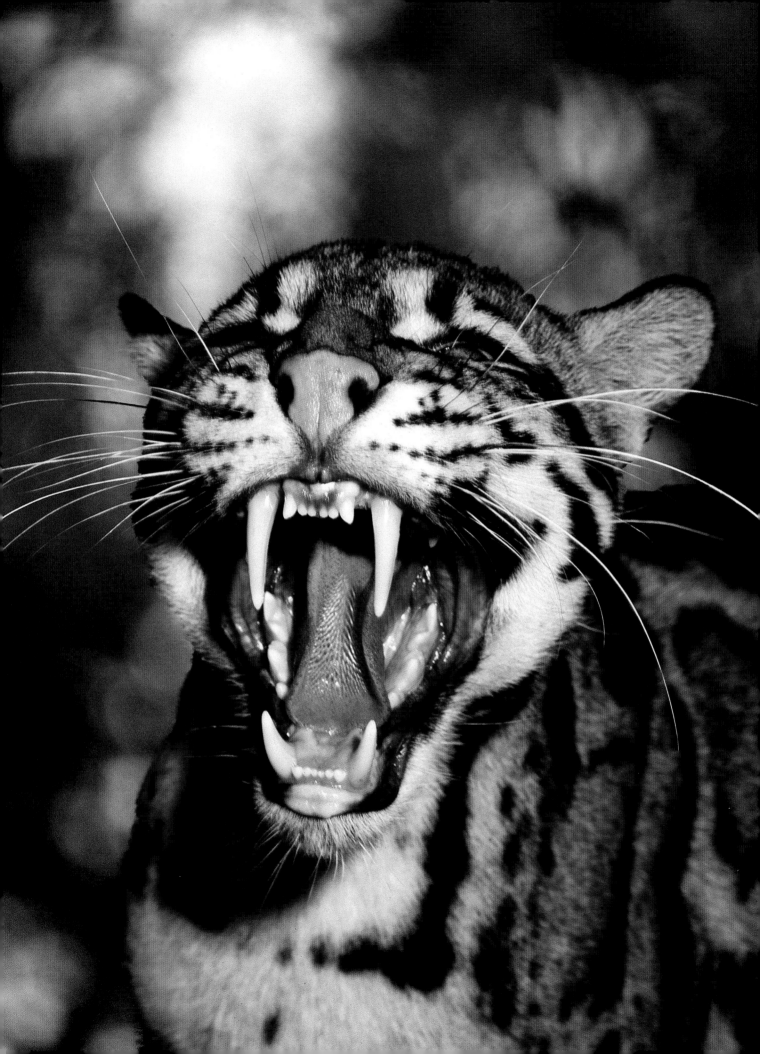

turning your photographs
into paintings

chapter | **SIX**

ACHIEVING PAINTERLY EFFECTS WITH FILTERS

Technology now enables photographers to transform any photograph into something that is virtually indistinguishable from a painting. I use two different programs for this: Adobe Photoshop and Corel Painter (this program used to be called MetaCreations Painter and before that Fractal Design Painter). Often, I will use both programs on a photo, first abstracting it in one and then finalizing the color scheme or the amount of manipulation with the other.

The strategy I use within Photoshop is to use two or more filters in combination with each other until the image becomes abstracted to the point of looking like a work of art. I often use five or more filters on a single image until I am satisfied with the amount of abstraction. You may not have all of the filters I discuss in this chapter, but most of them are now built into Photoshop 6.0. You can purchase the others through the normal outlets.

Painter offers us a very different approach. Within this program, you can use brushes in the same way an artist would apply brush strokes to a canvas. You blend and mix the colors in the original photo as if you had dipped a brush into paint and were applying it. The many brushes available lay down color, and distort color, in different ways. By the time you are finished, no one would guess that the original image was a photograph.

The portrait at right is a good example of how I used many Photoshop filters to achieve a painterly interpretation. First I used **Filter: artistic: palette knife** and then **Filter: stylize: psycho**. I copied the combination of these filters to the clipboard with **Edit: paste**. Next, I clicked **File: revert** to revert the image to the original, unmanipulated portrait. I then hit **Edit: paste** to place the clipboard image over the original, below.

Next, I went to the **layers palette**, and in the pull-down

turning your photographs
into paintings

menu within the palette that combines the layers in various ways, I tried all the possibilities but liked **difference** the best. In the opacity slider scale, I opted for 54 percent. With **Layer: flatten image** I melded the layers together.

I then applied **Filter: blur: KPT Gaussian glow** twice and used **Image: adjust: levels** to lighten the result. I saved this new image with **File: save as** and gave the file a new name.

Finally, I applied **Filter: organic edges** (this filter gave me the texture) and again copied the result to the clipboard. I hit **File: revert** to go back to the last saved version and then used **Edit: paste** to superimpose the clipboard layer. To blend the two layers to my liking, I used **overlay** in the **layers palette** pull-down menu. I then used **Image: adjust: hue/saturation** to tweak the colors.

Mamiya RZ 67 II, 110mm normal lens, 1/60, f/5.6, Fujichrome Provia 100F, one photoflood, Fujichrome 64T, tripod.

Finding Successful Filter Combinations

You can continually use filter combinations until you like the result. If you end up with an unsuccessful image, simply revert back to the original and start over. It's difficult to preconceive the final results; simply experiment until you like what you get.

Two variations of a lotus flower are reproduced here. In the photo at top right, I started with **Filter: artistic: palette knife** and then **Filter: brush strokes: dark strokes**. I then saved the result as a new file with **File: save as**. Next I used **Filter: stylize: glowing edges** and copied the result to the clipboard with **Edit: copy**. I then reverted to the last saved version with **File: revert**. I used **Edit: paste** to place the clipboard image as a layer onto the reverted photo, and I chose **screen** in the pull-down menu in the **layers palette** to blend the layer. Finally, I used **Filter: blur: KPT Gaussian glow** twice and then **Filter: artistic: rough pastels**.

In the photo above right, I began with **Filter: artistic: palette knife** and then **Filter: brush strokes: dark strokes**. I saved the result as a new file. Next, I used **Filter: stylize: glowing edges** and copied the result to the clipboard with **Edit: copy**. I then reverted to the last saved version with **File: revert**. I used **Edit: paste** to place the clipboard image as a layer onto the reverted photo, and I chose **luminosity** in the pull-down menu in the **layers palette**. Finally, I used **Image: adjust: levels** to lighten the colors in the image.

Mamiya RZ 67 II, 350mm APO telephoto lens, 1/15, f/8, Fujichrome Provia 100F, tripod.

DISTORTING WITH BRUSH APPLICATIONS IN PAINTER

I took the photo at right (also shown on page 20) and applied several Photoshop filters before I opened it in Painter to apply a distortion brush. Then, I took it back into Photoshop for the finishing touches.

The Photoshop filters I used were **watercolor, fresco, dry brush** (under **Filter: artistic**) and **accented edges** (under **Filter: brushstrokes**). I saved this new image using **File: save as** and then opened Painter. This program requires a clone of the image to use brush applications on, so I made a clone (**File: clone**) rather than applying brushes directly on the photo itself. Next, in the **brushes palette**, I chose **Liquid: distorto** and used my Wacom pen to pull and smear the colors in the portrait. I avoided distorting the eyes, which would have altered the model's features beyond recognition. I saved this new version and opened the file in Photoshop again, where I altered the colors using **Image: adjust: hue/saturation**. To soften the effects I had just created, I applied **Filter: blur: KPT Gaussian glow**.

Mamiya RZ 67 II, 250mm telephoto, 1/30, f/4.5, Fujichrome Provia 100, window light, tripod.

USING THE FLEMISH RUB BRUSH

I abstracted this autumn foliage scene (left), taken in Vermont, solely in Painter. I cloned the image first with **File: clone** and then used my favorite brush, **Artists: Flemish rub** in the **brushes palette**. (This brush is in Painter 5.0, not 6.0). I selected the brush icon in the **brushes palette** and then, using the Wacom pen, I meticulously smeared the color, making sure every pixel was altered (below).

You can vary the size of the brush in the **Controls: brushes palette**. I usually use a brush size with a numerical value around 40. When I liked the result, I brought the image into Photoshop and used **Image: adjust: hue/saturation** to change the colors.

Mamiya RZ 67, 350mm telephoto, 1/60, f/5.6, Fujichrome Velvia, tripod.

CREATING PAINTINGLIKE COMPOSITES

All photos Mamiya RZ 67 II, tripod.
Horse: 110mm normal lens, 1/400,
f/5.6, Fujichrome Provia 100;
Canyon: 250mm telephoto, 1/2, f/32,
Fujichrome Velvia.

I hired this exquisite stallion and a horse trainer so I could photograph the animal rearing. I used the blue background in an attempt to make it easy to separate the horse from its background, but it really wasn't big enough, and the wind kept blowing the huge roll of painted paper (top left and top middle).

I used the **pen tool** in Photoshop to create a path around each horse. I ultimately intended to create a paintinglike composite, so critically outlining the hair on the tail and mane wasn't important. I converted the path to a selection in the **paths palette** by using the pull-down menu within the palette and choosing **make selection**. I copied each of the horses to the clipboard separately (**Edit: copy**) and pasted them one after the other into the background photo (**Edit: paste**, top right). With the **move tool**, I moved each horse into place. You can move each layer only after highlighting it in the **layers palette**.

Using the **burn/dodge tool**, I darkened the areas under the horse's hooves to create appropriate shadows. I then flattened the photo with **Layer: flatten image**.

I opened the image in Painter, made a clone (**File: clone**) and chose **Artists: Flemish rub** in the **brushes palette** to transform the picture into a painting. I used the brush icon in the brushes palette and applied brushstrokes to abstract the colors in the photo. Then I saved the photo and reopened it in Photoshop to tweak the color using **Image: adjust: hue/saturation**.

99

I took the picture above during the same shoot as the original horse photos on page 99. I separated the horse from the background, copied it to the clipboard and pasted it into the field of Texas bluebonnets exactly as described previously. I didn't have to cut the edge of the horse precisely due to the nature of the abstraction. I then opened the composite in Painter, made a clone with **File: clone** and used the same brush—**Artists: Flemish rub**. In this image, however, the brush size was much larger than in the previous image. I set the size in the **Controls: brushes palette** to 75 rather than 40. You can see how the larger strokes affected the blending of colors. I chose the brush icon in the tools palette and then applied the brushstrokes.

I saved the painterly image, opened it in Photoshop again and used **Image: adjust: hue/ saturation** for the final color scheme.

Horse: Mamiya RZ 67 II, 250mm telephoto, 1/250, f/8, Fujichrome Provia 100, tripod; Field of flowers: Mamiya 7, 43mm wide angle, 1/15, f/22.

Achieving Brilliant Effects Through Abstraction

I used one of the nik Color Efex Pro! filters here. It is very different from the graduated filters used for the final image on page 36. These filters are plug-ins for Photoshop, and they offer some remarkable effects. Some of the filters make subtle changes in color and contrast, while others are truly wild. My favorite filter in the "wild" category is pop art.

I opened the photo of the Carnival participant in Venice, Italy (right), and copied it to the clipboard (**Edit: copy**). I then clicked **Filter: nik Abstract Efex Pro: pop art** and created a wild abstraction of the original image. Next I pasted the clipboard photo over the abstraction with **Edit: paste** to create a layer. To get the effect you see here, I blended the layer and its background image in the **layers palette** by choosing **luminosity** from the pull-down menu. I flattened the combination using **Layer: flatten image** and changed the colors with **Image: adjust: hue/saturation**.

Mamiya RZ 67 II, 50mm wide angle, 1/60, f/4.5, Fujichrome Velvia, handheld.

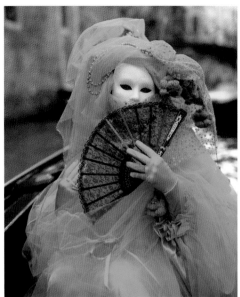

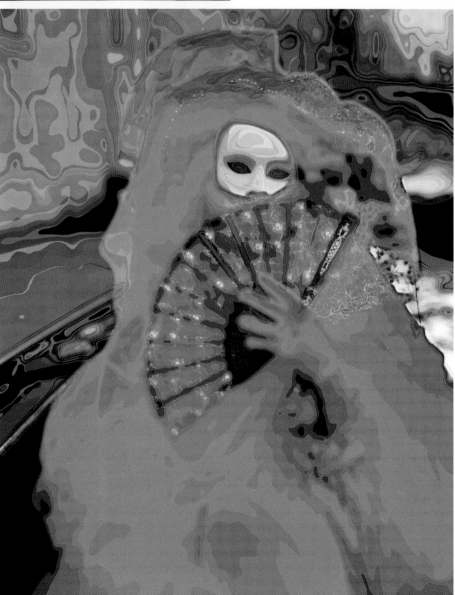

Outlining Semi-Transparent Materials

Similar to the photo of the Carnival participant on page 83, I photographed a model in the studio against a monochromatic background specifically to cut and paste the component into another scene. I took several shots of her in various poses; I used the two you see here for the final composite. I separated her by selecting the background with the **magic wand tool** and clicking **Select: inverse** to select everything except the background, which of course left only the model.

I took the photo at right in Venice. I wanted to use the out-of-focus background for the new image, but I had to cover the original model. To do this I simply copied the first photo of the new model (bottom left) to the clipboard, pasted it into photo at right with **Edit: paste**, and moved it into place with the **move tool**. I followed the same procedure for the second photo (bottom right). When both of the new images were in place, they covered virtually the entire red costume of the original model. I flattened all the layers with **Layer: flatten image** and then used the **clone tool** to eliminate telltale areas of red that were still visible.

I originally intended to cut out not only the model from the gray background, but the netting of her costume as well. I wanted the actual netting material to be included in the layer. I worked on this image before the Knock-Out program was available (used on page 91), so the ultrafine detail in the netting material presented a significant problem for me. In the end, I couldn't do it. To cover the poor cutout of the model and her costume, I abstracted the details of the components with Painter. The brush-strokes camouflaged the flaws

(opposite page).

I opened the composite in Painter, hit **File: clone** and chose **Artists: Flemish rub** in the **brushes palette**. I adjusted the brush size brush in the **Controls: brushes palette**, clicked on the brush icon in the tools palette, and applied the brushstrokes to the photo. Upon completion, I saved the new image and then opened it in Photoshop. I selected the final colors in **Image: adjust: hue/saturation**.

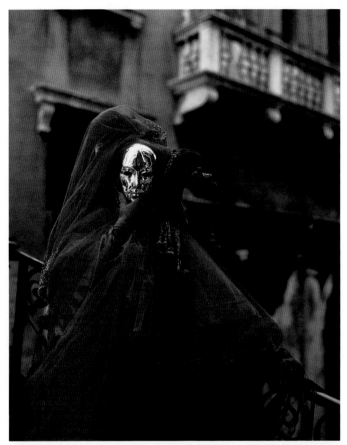

All photos Mamiya RZ 67 II, Fujichrome Velvia, tripod. Model in orange costume: 110mm normal lens, 1/60, f/4; Model in yellow costume: 50mm, Speedotron Power Pack with two strobe heads and two Photoflex softboxes, f/16.

ABSTRACTING WITH BRUSHES IN PAINTER

In Photoshop, I vertically cropped the horizontal shot of the snarling wolf (right) with the cropping tool in the tools palette. I then opened the image in Painter and, after making a clone (**File: clone**), I chose the brush **liquid: total oil**. I clicked on the brush icon in the tools palette and chose a moderate brush size of 40 in the **Controls: brushes palette**. When I abstracted the eyes, however, I used a smaller brush size of 12 because I didn't want to distort the form of each eye. This is very important, because it's easy to abstract the form of a face to such a degree that it becomes unrecognizable.

Mamiya RZ 67, 500mm APO telephoto, 1/250, f/6, Fujichrome Provia 100, tripod.

Adjusting Color for Seamless Composites

With the **magic wand tool**, I selected two frigate birds in the Galápagos Islands (near right) and copied them to the clipboard (**Edit: copy**). I pasted them into the sky above the Alcazar in Segovia, Spain (far right), using **Edit: paste**. I resized the birds with **Edit: transform: scale** and merged the layer with its background with **Layer: flatten image**.

Next, I opened Painter and made a clone (**File: clone**). I selected the brush icon in the tools palette and chose **Chaulk: squre chaulk** in the brushes palette. I used a medium-size brush and abstracted the entire picture. I then used the pull-down menu **Effects: tonal control: adjust colors** to alter the color scheme; this is similar to hue/saturation in Photoshop. Finally, I applied **Effects: focus: glass distortion**.

Both photos Mamiya RZ 67 II. Frigate birds: 350mm APO telephoto, 1/250, f/5.6, Fujichrome Provia 100, hand-held from a boat. Alcazar: 1/60, f/5.6, Fujichrome Velvia, tripod.

special
techniques

chapter | **SEVEN**

The first chapter in this book illustrates how you can use the computer to simulate darkroom effects. Once you delve into the inner workings of Photoshop and some of the other programs and plug-in filters, it becomes obvious that your ability to digitally alter photographs goes far beyond anything possible in the darkroom. The problem I'm often faced with is there are so many ways an image can be modified, enhanced and composited that it's hard to know where to begin.

This chapter describes some fascinating techniques that will give you additional tools to make dramatic statements with your photography. Keep in mind that when you see a particular technique applied to a photograph, it may not work with another image. For example, the close-up of a frog that I distorted using liquify in Photoshop 6.0 (below right) may look silly when turned into a mosaic as on page 113. And the reverse is true. The portrait I used for the mosaic technique on page 112 probably would not work when distorted beyond recognition with liquify. Many of the pictures in this book came about by trial and error. Sometimes I preconceived them. Other times I said, "What if …," and then experimented.

What you are not seeing on these pages are the images that didn't work out.

special
techniques

DISTORTING PHOTOGRAPHS FOR UNUSUAL EFFECTS

In Photoshop 6.0 there is a technique that enables you to distort a photograph to bizarre proportions. I chose a photo of an African pixie frog that I photographed in a pet store as my subject. The face seemed appropriate for distortion. I clicked **Image: liquify**, and a new set of tools appeared on the left side of the monitor. Some of the tools allow you to expand portions of the image while others contract, or squoosh, the pixels together. In the upper right-hand corner, you can choose a brush size.

If you have friends who have offended you in some way, this is a comical way to get back at them. Use liquify on their picture and send them a copy!

Mamiya RZ 67 II, 110mm normal lens, #1 extension tube, f/22, Metz 45 flash, Fujichrome Provia 100, handheld.

CREATING A HAND-COLORED EFFECT

Canon EOS 1, 50-200, zoom lens, exposure unrecorded, Kodak Tri-X film, handheld.

Hand-coloring black-and-white prints has been popular since the inception of photography. In Photoshop, you can simulate a hand-colored photo without spending time in the darkroom or purchasing expensive oil paint kits.

The three sets of photographs reproduced here and on pages 110–111 show you how you can digitally transform an original photograph into a hand-colored image. Instead of paints, I used the **airbrush tool** in the **tools palette** to apply color to selected areas. In some instances, I selected a specific area using the **magic wand tool** or the **pen tool**. Then, I chose a brush size and sprayed color into the selection. In other cases, I simply applied the color without a selection. When I was finished, I might tweak the color using **Image: adjust: hue/saturation** or diffuse the photograph, as I did with Anif Castle in Austria (page 111), by applying **Filter: blur: Gaussian glow**.

Contrast the softness of the castle with the portrait of the Indian dancer (page 110). When I photographed the young woman, I used a diffusion filter.

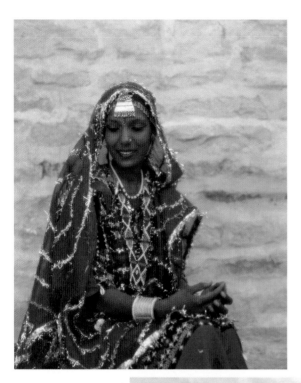

Mamiya RZ 67 II,
110mm normal lens,
diffusion filter,
Fujichrome Provia 100,
1/60, f/5.6, tripod

Mamiya RZ 67, 110mm
normal lens, 1/60, f/4,
Fujichrome Velvia, tri-
pod.

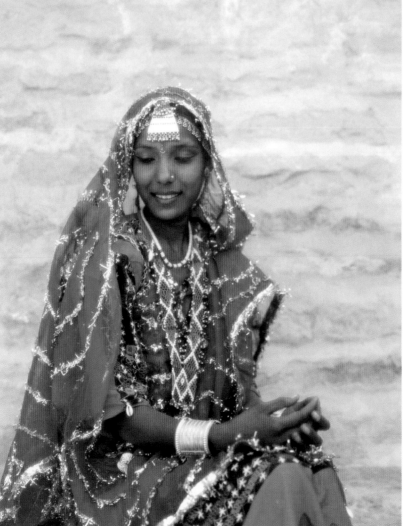

Transforming Photos Into Mosaics

In Painter, there is a wonderful technique that enables you to transform a photograph into what looks like a mosaic. The procedure requires an investment in time (the image at far right took about forty-five minutes), but the results can be fascinating.

I opened the original portrait in Painter and then clicked **File: clone** to make a copy of the image. Next, using the pull-down menus, I chose **Canvas: make mosaic**. At this point the cloned image was now completely white, and a dialog box opened. The first thing I did was click the "use tracing paper" box. Now, you could see the image through what looks like a sheet of white tracing paper. I adjusted the slider bars of "width" and "length" to define the size of the mosaic tiles (for this image, I used the numeric value of 24 for both dimensions) then I simply applied the tiles with my Wacom pen (you can also use your mouse).

Before you do this, however, it is very important that you go to the **Artist materials: color palette** and click the box "use clone color." If you don't do this, you won't get the underlying colors from the original photo for the tiles.

To underscore the features in the portrait—the eyes, lips, and shape of the face—I first applied tiles that followed these lines. I then used long rows of "tiles" to define the hair and filled in the rest of the image randomly. When I was finished, I clicked **done** in the dialog box and then saved the cloned image to the desktop. I cropped the final version you see here in Photoshop using the **cropping tool**.

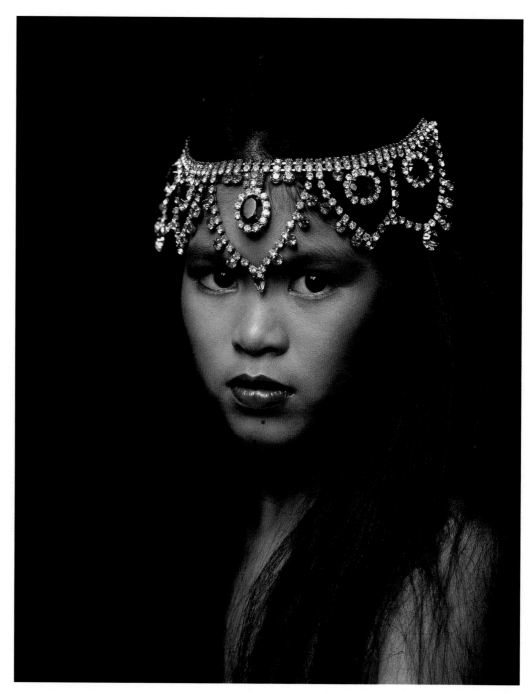

Mamiya RZ 67, 180mm telephoto lens, Speedotron Power Pack, one flash head and one Photoflex white umbrella, f/16, Fujichrome 50, tripod.

CREATING ABSTRACT IMAGES

You can easily generate amazing abstract images with Photoshop and with another program I use called ArtMatic. In Photoshop, Kai's Power Tools (KPT) 5.0 offers FraxPlorer, a fractal generating option. It is simple to use, and as you experiment with the various buttons and slider bars in the program, you will be impressed with the intricate and often complex designs that you can generate. Simply open a new document in Photoshop with **File: new** and then choose **Filter: KPT 5.0: FraxPlorer**. I made the photos on this page with this program.

ArtMatic is another program you can use to generate different kinds of abstracts. Again, depending on your choices within the program (which is very intuitive and easy to understand), you can produce an endless number of designs and colors. Of course, once you have a basic abstract, you can alter it using other aspects of Photoshop, such as Terrazzo (see the photos on pages 30 and 31) and **Filter: distort**. I made the four photos on this page with ArtMatic.

Once you have a collection of abstracts, what do you do with them? The photos on on these two pages show how I've incorporated some of these colorful designs into my photography. I use them as backgrounds, layers and components.

AUGMENTING LIGHTING IN YOUR PHOTOGRAPHS

Within Photoshop there is a means for you to manipulate the lighting in an original photograph. You can't alter the actual shadows and highlights or the direction of the main light source, but you can add spotlights, beams of light and colored lights. You can also increase or decrease the ambient light relative to the subject. These controls are found with **Filter: render: lighting effects**. The dialog box that opens is easy to understand, and there is a small preview window in which you can view the effect before rendering it.

Michelangelo's *David* (left) is a classic shot you've probably seen many times. The marble sculpture is illuminated with a single overhead dome that allows soft daylight to filter into the museum. Below left and right are two examples of how I digitally introduced additional lighting.

Mamiya RZ 67, 110mm normal lens, 1/30, f/2.8, Fujichrome Velvia, tripod.

CREATING A BLUR EFFECT

When zoom lenses were first developed, photographers learned that during a relatively long exposure, they could move the lens from one focal length to the other to create streaks of color. This zoom blur effect suggested action or speed. Both Photoshop and Painter have filters that allow you to create the same effect, but now you have total control over the amount of blur and the placement of the center of the blur.

I opened the gondolier (below left) in Painter, and I clicked the pull-down menu option **Effects: focus: motion blur**. In the dialog box that opened, I placed the center of the blur at the top of the dome, selected the other parameters (radius, angle, thinness) and clicked OK. I then saved the new image, closed Painter and opened Photoshop. Using **Image: adjust: replace color**, I played with the eyedropper and slider bars until I had infused the photo with new colors. Using the **cropping tool**, I cropped the photo to eliminate much of the featureless sky.

Mamiya RZ 67, 50mm wide angle, 1/125, f/8, Cokin gradient filter, Fujichrome Velvia, handheld in boat.

Using a Planar Tiling Effect

Mamiya RZ 67 II, 110mm normal lens, Speedotron Power Pack with one flash head and one Photoflex softbox, f/16, Fujichrome Velvia, tripod.

In Kai's Power Tools 3.0 there is an option called planar tiling. This transforms a photograph into a perspective plane. In the final image at far right, I used the **planar tiling** command twice: once for the background and once for the entire frame.

I originally photographed the New Orleans Mardi Gras mask (above) with artificial eyes taped to the eye sockets. (I borrowed them from an eye doctor.) In Photoshop, I selected the mask with the **lasso tool** in the **tools palette** to make a rough outline around the face. I held the option key down and, with the **move tool** selected, moved a clone of the mask to the other side of the frame. I clicked **Edit: transform: flip horizontal** to flip the clone so it was facing itself. I moved it into place with the **move tool**.

I selected the abstract background (above right) with **Select: select all** and copied it to the clipboard with **Edit: copy**. In the photo of the two masks, I selected the black area with the **magic wand tool** and then used **Edit:**

paste into to replace the black with the green abstract.

With only the background layer selected, I clicked **Filter: KPT 3.0: planar tiling**. To lay down the abstract in a perspective plane. I flattened the layer with **Layer: flatten image** and then applied the **planar tiling** command again to the entire image.

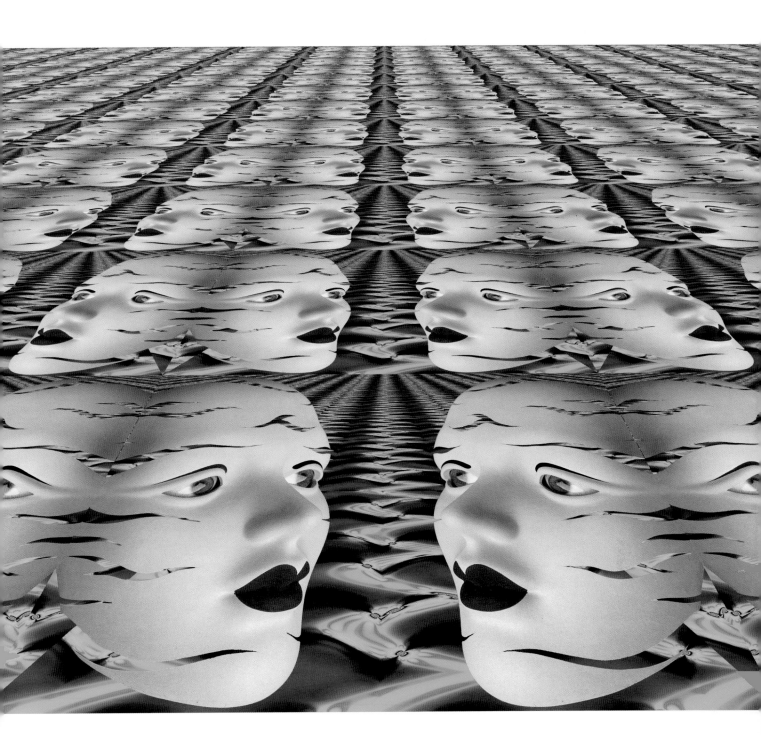

Using Multiple Photos for Surreal Effects

I made the surreal composite on page 123 by combing a ballerina photographed in a studio, an aquarium fish shot against a blue background positioned behind the water, clouds above a lagoon in Bora Bora and one of the rock structures at Stonehenge in England. I did not preconceive this image. I simply played with the components until I liked the result.

Notice how the rock face attenuates, or fades away, at its base. I did this with a layer mask.

My first step in creating this image was to make the background. I opened the picture of the clouds (bottom left) in Photoshop and, using the **rectangular marquee tool** in the **tools palette**, I made a selection of the sky. Holding the option key down, I dragged a copy of the selection to the bottom of the frame. With **Edit: transform: flip vertical**, I flipped the copy, and with the **move tool** I moved it into place to mirror the upper portion of the photo.

Next, I placed the rocks (top right). I used the **pen tool** to create a path around the structure, and then turned the path into a selection in the **paths palette** with the pull-down menu option **make selection**. I copied this to the clipboard with **Edit: copy** and then pasted it into the background using **Edit: paste**. I used the **move tool** to move it into place.

To fade the bottom portion of the rocks, I chose **Layer: add layer mask: reveal all**. I clicked on the **gradient tool** in the **tool palette**, and made sure that white and black showed in the foreground and background color boxes (in the **tools palette**), respectively. Using my Wacom pen, I moved the cursor from the top of the rocks to the bottom and achieved the result I wanted.

Next, I selected the fish (bottom right) and pasted it into the composition several times. I had to reduce it in size using **Edit: transform: scale**. (I held down the shift key as I dragged a corner of the box that forms around the layer. This maintains the correct proportion.) In the **layers palette**, I used the pull-down menu and chose **lighten** to allow the background to combine with the colors in the fish as you see it here.

Finally, I cut, pasted and positioned the ballerina (top left) above the rock. I selected her leotard with the **magic wand tool** and changed the black to red in **Image: adjust: hue/saturation**.

All photos Mamiya RZ 67 II. Ballerina: 110mm normal lens, Speedotron Power Pack and two flash heads with two Photoflex white umbrellas, f/11, Fujichrome Velvia, tripod; Fish: 110mm normal lens, #1 extension tube, Metz 45 flash, f/11, Fujichrome Velvia, handheld; Water and sky: 50mm wide angle, 1/125, f/8, Fujichrome Velvia, handheld in boat; Stonehenge: 250mm telephoto, 1/4, f/16, tripod.

outputting your images

chapter EIGHT

Once you have scanned and manipulated your photographs, you have many options for converting the digital files into usable and enjoyable visual presentations. In the past, photographers made various kinds of prints in the darkroom to display their work: Type R, Type C, dye transfer, Cibachrome, gum bichromate and platinum prints are examples. In my opinion, the quality of digital outputs is far superior to traditional methods of printing, plus you have a level of control unknown in the past.

The ease of printing your work has also changed radically. In the past, when I wanted to create a new portfolio, I'd select the originals and take them to the photo lab. Several days later, I'd drive back to the lab and pick them up. Now I scan the photographs in my home office and print them out right on my desk in just a few minutes. And the quality of my printer, which I bought for around $450, is better than the lab I'd been using for a decade. The colors are richer, it's extremely sharp, and an 8″ × 10″ costs me about one dollar.

It is definitely a great time to be a photographer.

outputting your images

Desktop Printing

I never thought I'd say this, but I now believe that prints made right on my desktop with an Epson color printer are better than the conventional Type R prints at a photo lab. The depth of color and the resolution are exceptional. I prefer matte paper, but the Epson glossy emulsion produces superb prints as well. If you like colors that scream, you'll love the glossy paper.

At this writing, I'm using the Epson 1270. It is fast, quiet and completes an 8½″ × 11″ inch print in about four minutes. It will print up to 13″ × 19″.

The Epson 2000 uses inks that are considered archival, where the colors are supposed to last 150 to 200 years. (This is determined by accelerated light tests, but no one knows for sure.) If the archival quality of prints is important to you, this is the printer for you. The 2000 isn't designed to print letters, and it is twice as expensive as the 1270. The inks are also more costly.

One of the difficulties you can encounter in conventional darkroom procedures is reproducing certain colors accurately. Bright orange, saturated blue-purple and yellow-green tones are especially tough. The colors in the photos here and on page 128 are challenging to render on photographic paper. However, with the Epson 1270 and Epson matte or glossy paper, even these colors are outstanding. (Note that the intensity of the colors you see on a computer monitor is somewhat different than on printed paper, whether you are looking at an Epson print or the images here. Pigment- or dye-based inks on paper don't look exactly like the light-emitting phosphors on a computer monitor. So, matching a printed page to the monitor is an art as well as a science, and while it comes close, it is never precisely the same.)

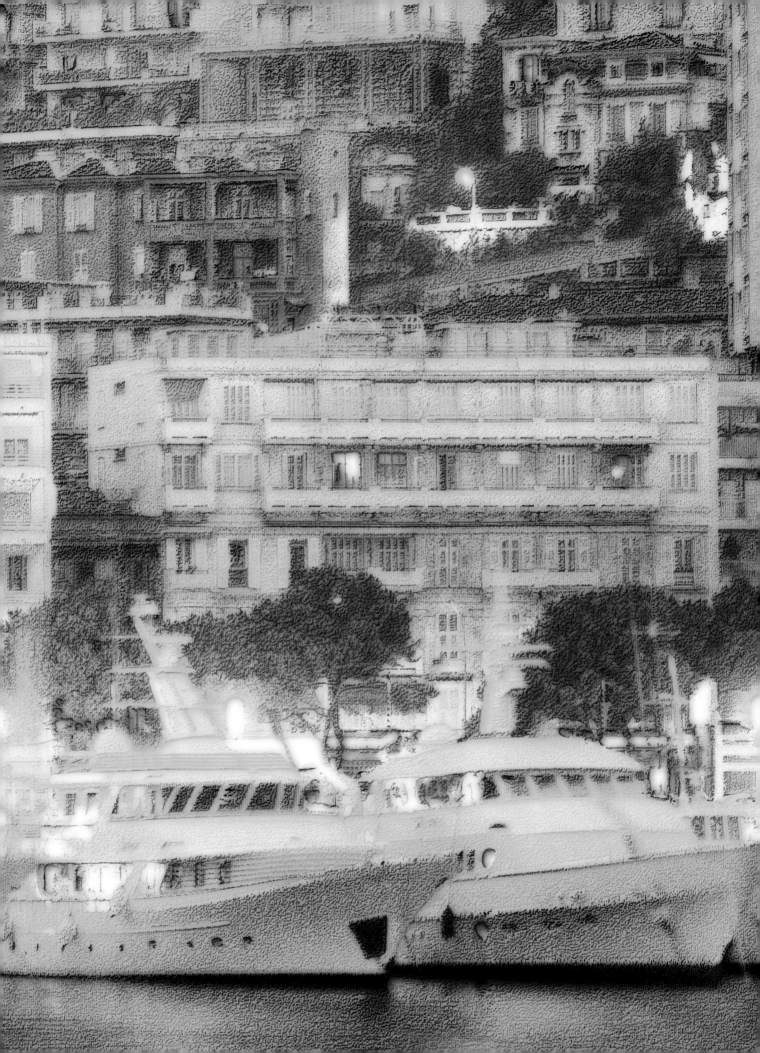

Outputting to Transparencies

If you like giving slide shows, you'll want to output your digitally manipulated photographs to transparency film. Since I shoot medium format, I output my images to 6 × 7cm so they fit into my Gepe glass mounts for projection. However, 35mm output slides are also available. The machine that transfers a digital file to film is called a film recorder.

I've used two types of film recorders. A Solitaire is less expensive and produces a good slide, and most service bureaus have this type of unit. The better choice, however, is an LVT film recorder. Images from an LVT are sharper and richer in color, and they are more expensive as well.

One of the challenges in converting digital files to film is a gain in contrast. The same problem exists when making dupli-cate transparencies. The photo below is already low in contrast, and any gain will be minimal and hardly noticeable. However, the normal tonal values in the photo on page 131 will exhibit a subtle gain in contrast that is un-avoidable. When you view your output transparencies, be aware that this problem is simply inher-ent in the process. One way to minimize it is to slightly reduce the contrast in the digital file

CALIBRATION

CALIBRATION

Calibrating your monitor means that you tweak the color balance and contrast to match an output device, such as a desktop printer, a film recorder or another monitor. This is necessary to make sure that what you see on your computer is what you get when a print, slide or color separation is made from your work.

To calibrate your monitor, first open the control panel **Adobe Gamma**. The dialog boxes that follow take you step by step through the process, with simple explanations along the way. This takes about ten minutes.

When you start working with a service bureau that outputs transparencies, Iris prints or prints on canvas, you can calibrate your monitor to the bureau's equipment by using a Color Calibration Kit that the bureau will provide for you at no charge. The bureau will explain how to use it, and once you are dialed in to the correct color values, all of your work will be reproduced according to the original color balance of your images.

129

within Photoshop. Try using **Image: adjust: brightness/ contrast**. To reduce the cost of LVT outputs, I do the setup in Photoshop before I bring the digital file to the service bureau. A portion of the bureau's fee is the time a lab technician spends preparing the images for output. Since an LVT film recorder can output transparencies to large format pieces of film, such as 4″ × 5″ and 8″ × 10″, I place nine 6 × 7cm images on an 8″ × 10″, as you see below. When I get the film back, I carefully cut out each photo (leaving a small black border) and then mount them for projection. You can also do this with 35mm by placing many more pictures on the 8″ × 10″ sheet of film.

Iris Prints

My favorite output method is done on an Iris printer. Iris prints can be made on any type of art paper. The saturation of the archival inks depends on the absorption qualities of the paper you've chosen as well as its color. White papers present color more brilliantly, while cream or yellow-toned surfaces mute the colors in the original image. My favorite paper is called Somerset. It is a warm, white, textured matte paper, and the 34″ × 47″ prints I've made are truly exquisite. This process transforms original, unmanipulated photographs or digital special effects into art that is worthy of a gallery exhibition. Unfortunately, I cannot represent how beautiful these prints are in this book because the types of paper and the lithographic processes are so different. You have to see them in person to fully appreciate this technology.

Translating the colors in your digital file to an Iris print is sometimes tricky. The service bureau that offers this service will give you one or two test prints to evaluate. You will then assess how much alteration is needed, if any. Some colors, particularly in the cobalt-blue/purple range, are tough to accurately reproduce.

CD-ROM

CD-ROMs are an invaluable tool for archival storage of digital files. I also use them as compact and easy-to-mail portfolios. Although I still use the traditional portfolio presentation of a collection of prints (printed from my Epson 1270), more frequently now I present my work on a CD-ROM. I burn a CD with a group of images for a proposal to a client, such as a new book idea or a one-man calendar. In addition, I can create a virtual "slide show" using Kai's Power Show. This program allows you to add music to a presentation and offers dozens of ways for one image to dissolve into another. It's a slick way to present photography. All of this is done on a CD-ROM, but if you want to output the slide presentation to a TV, all you need is the appropriate cable. Then you can view the entire collection of images—plus music—on a TV.

131

Color Span 7000

Some service bureaus have an output device that can make enormous prints. The Color Span 7000 is an eight-color printer featuring 1800 dpi; it can make prints as large as six feet by eighty-five feet (in case you have a large living room). Of course, it can also make smaller prints. The cost is on a per-foot basis. My lab charges about nine dollars per square foot (Print Tek, Chatsworth, California, [818] 576-0560).

I use the Color Span to print my images onto canvas. Large rolls of canvas are fed through the machine while the ink jet head lays down the color. The cost for this service is about four-teen dollars per square foot. Digitally manipulated images, especially ones that simulate oil paintings like the two images shown here, look especially beau-tiful on this material. They really seem like works of art. Any type of photograph, though, can be printed on this material. The im-ages look sharp, the depth of color is impressive, and the tex-ture adds a nice quality. When the piece is framed, the canvas is pulled taut just like an original oil or acrylic painting.

An advantage that an image on canvas has over one printed on paper is that canvas doesn't crease. You can bend it or fold it and no permanent damage occurs. Paper is not so forgiving. When I ship a large paper print to a client, I usually roll it and send it in a sturdy mailing tube. Even with care, a dimple or crease can occur during trans-port. With a canvas print, this is not a problem.

index